THE
TECHNIQUE OF

GLASS
FORMING

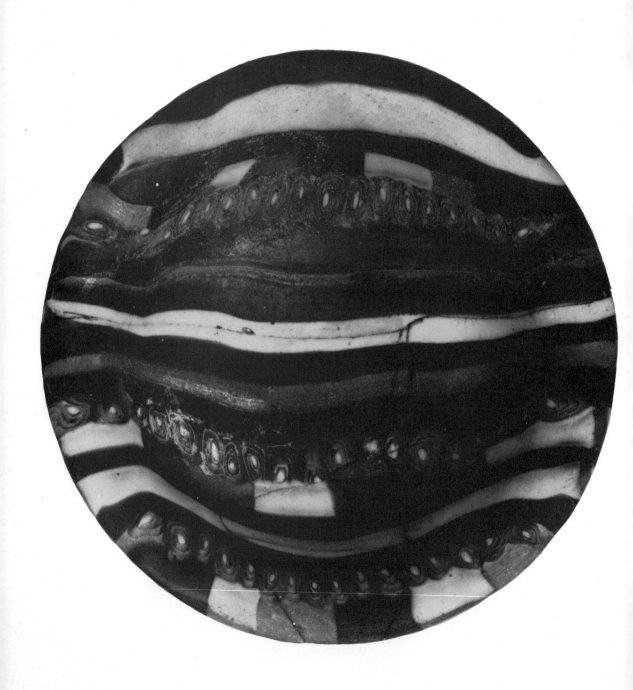

THE TECHNIQUE OF
GLASS FORMING

KEITH CUMMINGS

B T Batsford Ltd London

ISBN 0 7134 1612 2
80-509474
Filmset in 'Monophoto' Bembo by
Servis Filmsetting Ltd, Manchester
Printed in Great Britain by
The Anchor Press Ltd, Tiptree, Essex
for the publishers B T Batsford Ltd
4 Fitzhardinge Street, London W1H 0AH

Contents

Acknowledgment

The author and publishers would like to thank the following individuals and institutions for their kind permission to reproduce copyright photographs: the British Museum for figures 2, 4, 9, 14, 16, 18, 19, 25, 30, 32–4, 36, 40, 43, 47, 50; the City of Bristol Museum and Art Gallery for figures 3, 10, 15, 17, 29, 46; Dudley Art Gallery for figure 182; the Glass and Glazing Federation for figures 162–6; Rob Moore for figures 6, 73–4, 90, 93, 99, 102, 119–21, 128, 130–3, 136, 138–143, 150, 183; the Pilkington Archives for figures 51–9; the Pilkington Museum for figures 5, 48, 173; the Victoria and Albert Museum for figures 26, 41, 49, 174.

Colour photographs 4, 7, and the back jacket illustration are by Rob Moore, and 1 and the front jacket illustration are by John Smith.

Introduction

Glass in scientific terms is a unique material; it has been necessary for scientists to invent the term 'glassy state' to describe its material properties It fits into neither solid nor liquid categories but has a mix of characteristics. This mix gives it distinct behaviour patterns in relation to heat. At room temperature it is a frozen liquid with some of the properties of a genuine solid. As the temperature is raised, its viscosity changes gradually; it does not boil and evaporate like a liquid or suddenly flow at an exact temperature like metal. Instead it goes through a number of changes as it converts from solid to liquid, it will bend like rubber, stretch like elastic, flow like thick porridge, run like thin treacle. At any of these points a rapid fall in temperature will freeze the glass into the form which it has adopted at a specific moment.

By manipulating glass in its various viscous states it can be made to adopt many different forms, from a variety of types of solid, rod, tube, sheet, block, strand, to particles which can vary in size from that of a large marble to a grain of fine flour. These raw material forms of glass can be used to construct objects with the help of heat again. As each form reacts in a slightly different way to the heat process, their choice and juxtaposition will affect the object made from them.

As the heat-transformation of glass is about softening, stretching and flowing, the environment in which these take place is a crucial part of the forming process. Whether the glass is supported or suspended, for instance, will affect its shaping. Such constraints can vary from conventional moulds to arrangements of wires, hooks, or weights. The heat-forming equation consists of:

1 glass and its properties
2 variable heat
3 the choice of basic glass solids
4 the constraints by which the glass is encouraged to form in certain ways.

There is another element which is crucial, that of function; the choice of object to manufacture, using the equation and the relationship of objects to society.

The techniques studied in this book are not those suited to mass-production; this automatically makes them into one-off or limited-series methods, which means that the objects produced by these methods must justify themselves by being unique, luxurious or expressive rather than useful.

It is worthwhile looking at the broad span of glass history to see how heat-formed glass stands in relation to mouth-blown glass.

Glass has existed as a material created and used by man since at least 2000 BC. That is the current guess based on present archaeological evidence. At the moment we can conveniently say that the momentous invention of glass-blowing occurs half-way in the 4000-year history of glass and that for the first 2000 years objects were produced by heat-forming methods.

A number of things confuse us and prevent the accurate appraisal of glass-objects made before blowing. We presume that blowing made all previous techniques redundant and this is further compounded by the fact that these techniques did gradually disappear with the inception of blowing. It is important to look deeper than techniques to understand the circumstances which caused mouth-blowing to emerge when it did. Like most great inventions it came when it was needed. The Romans wanted quickly-produced, contamination-free containers to transport the precious liquids of its empire; wines, perfumes, etc. So inflating hot, soft glass to make vessels which had been technically and theoretically possible for centuries became a necessity.

The mistake occurs however, if we presume that pre-blown objects were the result of the same kind of pressures and that blown containers are superior versions of containers made by antiquated and out-dated methods.

In fact the whole culture of the Roman Empire was very different from the Hellenistic, Egyptian and Mesopotamian which preceded it, and their use of glass reflected this difference of cultural attitude. Here we encounter a difficulty, we understand the Roman culture because it is the forerunner of our own. We can identify with it, appreciate and evaluate its objects from a more or less shared set of criteria. We also know much more about the last two millenia and are left with few mysteries regarding the techniques of glass-making during this period. The reverse of this is that we know little of pre-Roman glass, its processes, functions, visual language, and share little of the religious, economic and cultural outlook which informed the societies which used glass in such rich and inventive ways.

Despite the scarcity of genuine hard evidence, it is worth attempting to identify some of the attitudes to glass and to speculate on some of the techniques by which it was formed in this long period. There are two good reasons for the attempt. The first is to create an informed climate in which the surviving examples of the first 2000 years can be appreciated for something approaching their real worth. The mysteries which surround their manufacture, in my opinion, prevent us from doing this. Instead we separate them into convenient classifications of colour, shape or origin

rather than seeing them as part of a rich vocabulary which is made up from a number of connected techniques.

The second reason for the attempt is that such a study will provide the background to the present use of glass as a heat-formed material from which to produce exclusive objects. Our own attitude to glass has undergone a revolution during the past century when, in common with other craft materials it has begun to adopt a new place in society, that of expressive medium or educational tool. As a result techniques which have been dormant since the birth of Christ are being re-discovered.

To study ancient and contemporary methods of working in the same book has certain advantages. Similarities and differences become evident, and in this way the modern obtains an ancestry and the ancient a continuation. A number of important generalisations can be made at this point.

The skills used in heat forming are not direct manipulative controls requiring physical contact with the material and manual dexterity. They are rather skills of prediction and organisation through processes which are carried out within the closed, and largely inaccessible environment of a kiln. This contrasts sharply with clay work, where an object is fabricated prior to kiln firing. In heat forming, the glass is placed in a kiln in component form only and the heat process completes the forming cycle.

To view and work glass as a prized rarity material or as an educational tool has distinct advantages. It means that techniques which are not commercially exploitable by virtue of their time consumption can be allowed to develop and flourish. It absolves glass artefacts from the necessity to function well in a practical day-to-day sense, so that inherently fragile forms or glass types can be explored with the knowledge that their value will ensure their protection.

It is no accident that throughout history the great centres of glass making have been within areas of strong cultural, scientific and political importance. Glass is a synthetic which is made by combining different constituents to make a new man-made material. For this reason it can only emerge within a society which possesses a sophisticated range of expertise in other materials from which glass can take what it requires. In the Ancient world, glass borrowed from the highly developed technologies of ceramics, precious metals and the lapidary working of precious stones. In doing so it also borrowed some formal vocabulary and a set of attitudes towards its value, and acquired an exclusive éclat which, despite centuries of factory production, it has failed to entirely lose.

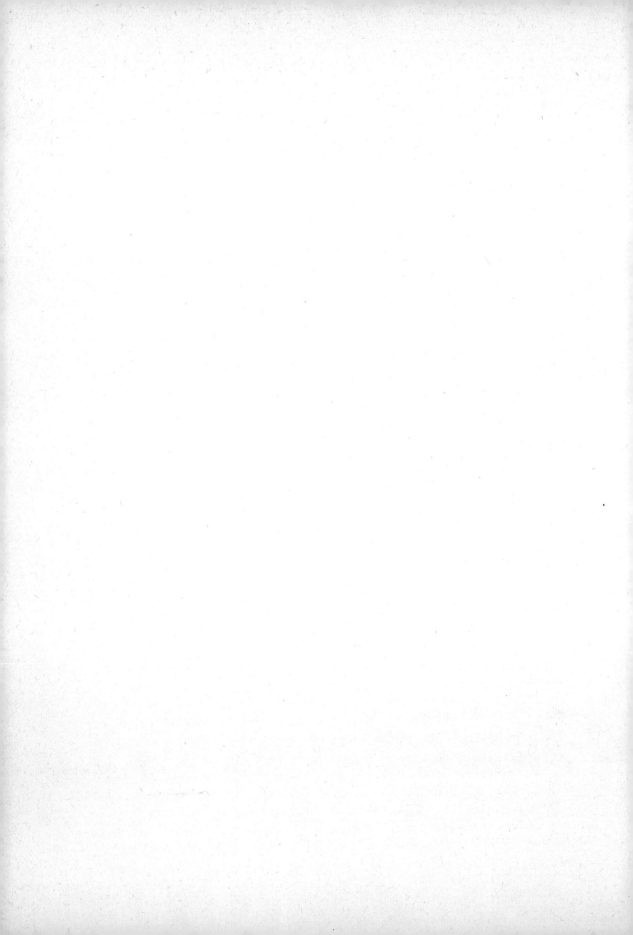

The history and development of glass forming

Glassmaking in Mesopotamia and Egypt

The area of the near east called Mesopotamia and which included Syria, Iran Anatolia and Elam was the cradle of glassmaking. Despite the fact that the high humidity of that area has meant that few glass objects have survived, we have the cuneiform texts from the Royal Library at Nineveh which tell us much of their methods of working glass and, through this, their attitudes to it. While glassmaking in Egypt is much better documented by well preserved surviving objects, there is little doubt that the Egyptians took as their foundation the knowledge of the Mesopotamian glassmakers, available in its written form, and that the Persian and Hellenistic glassmaking centres were directly or indirectly informed from the same source.

It is therefore worth looking at the texts (made possible by their publication in translated form in 1970: *Glass of Mesopotamia*, Brill, Oppenheim) and establishing what it was that these three separate schools of glassmaking took from them and which they all interpreted in their different ways.

Mesopotamian culture had been in existence for 1500 years before glass was used as an independent material. As already mentioned, glass is a synthetic which requires well established technologies in related fields to flourish, and its emergence was no exception.

The Mesopotamian methods of working materials was dominated by a geographical fact – the area was poor in natural materials; wood, stone and metal were all imported. This caused two things: a sparing respectful use of raw materials and a catalystic development for ceramic. Even fragments of stone were treated in a semi-precious fashion, which, related to clay-work and the scarcity value of other materials, meant that they developed a constructive way of working, making single objects from amalgams of many materials. This was particularly true of the surfaces of their products and buildings, which they inlayed and overlayed with mosaic.

The development of glass was made within this framework, and was informed and directed from a number of well established material technologies and traditions (figure 1). Prime among these was ceramic, which was well established by the middle of the second millenium BC, and the expertise of which contained much that was necessary for glass: sophisticated kilns, crucible and sagger production and, most important, a masterly control of glazes and their composition. Metalworking, particularly in gold and silver, was in an advanced state, employing techniques like lost-wax crucible casting and repoussé working of blanks, both of which techniques found equivalents in glass. Lapidary working, of a variety of stones and scales, and in cutting and polishing to create large vessels, small cylinder seals and gemstones. The main tool used was the cutting and polishing lathe (figure 2).

Although it was from ceramics that early glass took most of its techniques, it was with the metal and lapidary workers' products that it was most associated.

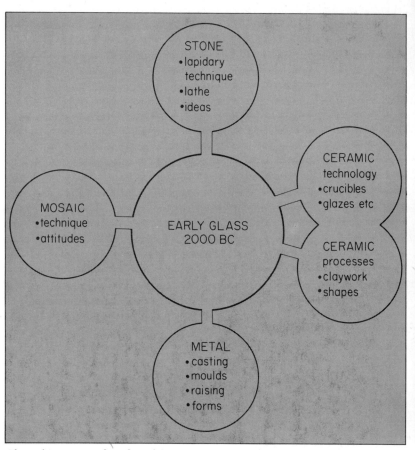

STONE
•lapidary technique
•lathe
•ideas

CERAMIC
technology
•crucibles
•glazes etc

MOSAIC
•technique
•attitudes

EARLY GLASS
2000 BC

CERAMIC
processes
•claywork
•shapes

METAL
•casting
•moulds
•raising
•forms

1 Glass, a synthetic material, was the result of a selective combination of other craft skills, their technologies, aesthetic attitudes and value systems.

Glass objects are often found in conjunction with precious metal objects and jewellery, indicating an equivalent value. It also seems that the goldsmiths and silversmiths combined glassmaking with their main skills, certainly as far as cast objects were concerned, where the glass object often closely followed the form of a metal original.

During the first flowering of glass in Mesopotamia from 1500 to 1000 BC the prime function of the glassmakers was to imitate the opaque, lustrous, semi-precious materials like lapis lazuli (red and blue), steatite, obsidian, agate and other natural hard-stones. They copied both colour and internal effects like streaking, layering and variegation. The techniques and tools developed to achieve this control are the first real glass processes, although their aim was imitation. In lists of materials from inventories of the time, stones like lapis lazuli are designated as natural by the suffix 'from the mountain' or artificial 'from the kiln'. Apart from this they were seen and used in exactly the same way, as raw materials to be cut, ground, polished and generally worked into a variety of objects.

A list of presents sent from Babylon to Egypt lists 31 lumps of glass in colours and forms relating to natural hard-stones, which gives an indication that their value was often no less than the real thing.

Although very few of these kiln-made precious stones are still in existence, their polished, ground surfaces making them especially vulnerable to decay, the descriptions of their production methods are worth investigation. They offer a very rich area for study and development as well as duplication. They show the

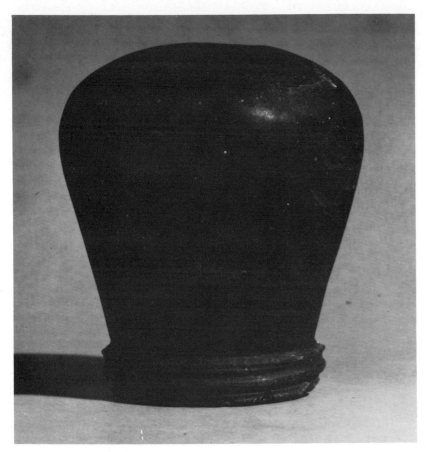

2 A Mesopotamian mace head: a solid cast lump of glass treated like a hard stone and lathe-turned into shape.

3 An Egyptian pendant (1500 BC): although it has been pierced it is virtually a standard ingot of glass, in which form the raw material was traded throughout the ancient world. Its granular appearance would suggest that it was cast from grains of glass.

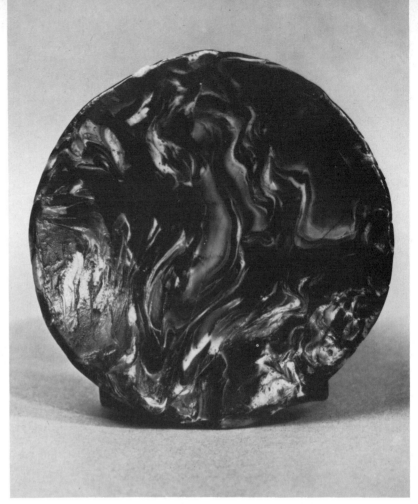

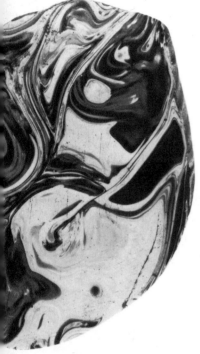

4 *Below* Alexandrian glass fragment: this crucible-poured glass was probably produced as raw material for mosaic inlay work. One side appears to have had a piece sawn from it.

5 A crucible-poured plate: the movement in the mixed colours suggests that this was made as a poured blank subsequently shaped. Three contrasting colours were placed cold into a ceramic crucible, heated and then poured.

sophistication and control of glass technology, particularly in colour range, which was taken up by later glassmakers. Glass is mentioned at this time as being made into beads, amulets, plaques and ceremonial mace-heads. All were made from the raw materials provided by the glassmaker, who at this time was a member of the elite craftsmen, partly because of the mysteries which surrounded its manufacture.

In common with other crafts, glassmaking was a ritual activity involving sacrifice and with strict codes of practice. The instructions are part practical and part magical. They had three different types of kiln for specific operations, one was assisted by bellows and all were fired by wood. They identified different kinds of kiln activity for which they used different kilns or different parts of the same kiln. In this way they could found glass in crucibles, sinter and mix different glass and colours in shallow open pans, and cast objects in closed ceramic boxes (saggers) which could remain in the kiln for a ten-day heating and cooling cycle. They employed multiple firings to create complex colours, poured liquid hot glass into water to shatter it into frit, add new ingredients and refine it. They manipulated glass within kilns by employing tongs to lift and pour crucibles, used rakes for stirring, turning and mixing glass in the open pans to obtain special internal effects, and used dipping rods to test for the levels of viscosity. They identified three distinct stages of viscosity, describing them in vivid visual terms as: (1) the forming of drops on a rod dipped into glass, (2) a thread created in the same way, and (3) the highest temperature, when poured glass 'coils like a snake' (figure 7).

6 A modern crucible pouring. By mixing colours in a crucible, pouring them and sawing a section from the resulting glass, it has been possible to demonstrate the ancient technique and establish it beyond doubt.

7 Hot glass as it begins to pour through an aperture and starts to 'coil like a snake'.

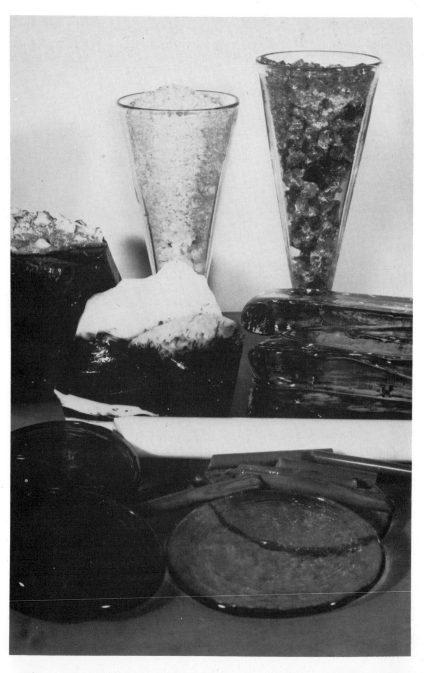

8 The raw material forms of glass available to the ancient glassmaker: lump, grain, powder, rod, blanks and ingots.

These stages, the direct equivalents of the already mentioned bending, stretching and pouring, were accompanied by precise colour descriptions of the degree of redness which related to the heat levels. These emphasise the visual nature of their controls in the absence of abstract equipment like thermo-couples and pyrometers. Direct visual control of glass within the kiln is a key aspect of modern glass forming despite such equipment. Their colour control extended to the creation of red in closed airtight crucibles.

Although these skills were used to create glass versions of artificial stones, it is

likely that they moved from the production of imitations to equivalents, but the importance lies in the inventive ways in which they handled their synthetic material, and the vocabulary of viscosity levels which they established and which form the basis of present day kiln working.

Glass before blowing has only been studied seriously since 1940, when Paul Fossing wrote his famous book on the subject, and it is only within the last decade that Mesopotamia has been recognised as having importance in the history of glass. Not only has humidity been unkind to glass preservation, but archaeologists have only recently begun to preserve small pieces of glass, found during excavations, as being worthy of study. We have descriptions of fragments as being 'closely packed striations of various coloured glasses ground smooth on both sides' but not the fragment itself. Such a piece would surely have been a practical example of their kiln-manipulated glass.

Their crucibles yielded about 3.5 litres (6 pints) of usable glass. This was utilised in a variety of ways (figure 8):

1 casting ingots to be traded or shipped to glassworkers of various kinds who would remelt or grind them

2 creating frits by pouring into water, for paste work or mixing to make colours and combinations of colour

3 pulling rods for cane work and for the beadmakers whose original raw materials these were

4 decanting into moulds placed empty into the kiln

5 allowing the crucible to cool as a solid lump which could then be broken into irregular stones for carving or inlay work

For many centuries glass has been called 'the metal' by its workers. Whatever the reason for this, it is interesting to note that in the cuneiform tablets glass is often called 'stone'.

These uses of the raw material established a pattern of working which was to influence subsequent schools of glassmaking by trade, marriage and the tablets which were copied and translated many times in the ancient world. The creation of ingots, blanks and frits, which were sent to separate glassmaking workshops for fabrication, is different from the centralised factory production methods of even the earliest blown-glass houses, where the raw materials of the basic glass batch entered and the finished glass objects came out.

With the fall of Assyria in 612 BC, the Persians became a major force in the Near East and produced in the fourth and fifth centuries some glass bowls which were the direct equivalents of their gold and silver productions (figure 9). In both this and the method adopted they were following much earlier precedents. Anita Engle (*Readings in Glass History*, Volume 1) states 'Finds in Mycenae dating from 1400 BC reveal the interesting fact that the same craftsmen apparently worked in gold and glass'. These bowls were probably produced by filling a mould, made by the lost-wax method, from a crucible. The empty mould and primed crucible were probably placed together in the same kiln (see figure 137); it would certainly have been necessary for the mould to be hot to encourage glass flow, for even at its least viscous, glass is a hundred times stiffer than water and will not fill a cold mould in the way that hot metal will. It is not surprising that goldworkers were able to add glass to their repertoire; they did not need to be able to found glass from batch, and having obtained ingots of it, the rest of the process is almost identical to metal casting, the same crucibles and moulds being quite acceptable.

Interesting though these Persian bowls are, the richest results of the

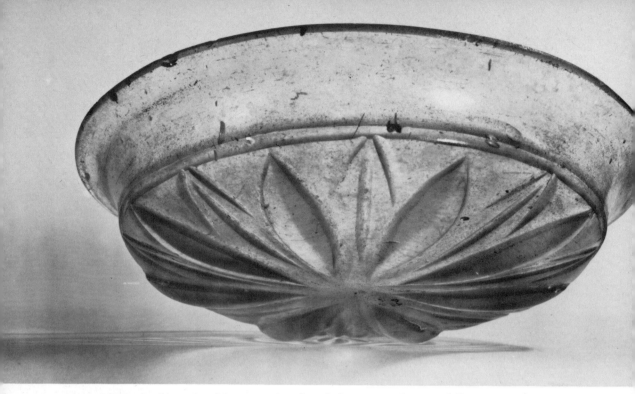

9 A Persian bowl (seventh century BC), made by the lost wax method and cast from a crucible like its gold and silver equivalents. Its entire surface has been ground and polished to remove any mould traces.

Mesopotamian foundations came from a different direction. Mention has already been made of the use of mosaic, a prime example being the famous decoration of temple columns at Uruk, with coloured ceramic cones pressed into their soft clay covering to create a multicoloured surface. This found its direct equivalent in glass with the mosaic glass beaker fragments dating from around 1400 BC. The technique appears to be the same as the columns and part of their tradition which produced stone vessels inlaid with coloured stones and mother of pearl.

The figures were made from cane section and set onto a cone, and the spaces were filled with a soft, low-fluxing glass; this was then covered by an outside former, and fired to set the glass flux. Inside and outside moulds would prevent distortion of the inlay and would be removed after firing. One example is made of rod inlays embedded in a bituminous compound which would mean that it was produced cold. Possibly the texts which mention rooms lined with glass tiles employed plaques made by these methods.

Whilst these mosaic beakers employ rod sections in a way which imitate their similar uses of other materials, they establish the employment of techniques which the Egyptians (and particularly the workers of Alexandria) developed a thousand years later. There were many links at this time between Egypt and Mesopotamia; marriage links between the royal houses included tributes. Thutmosis III received blue glass frit in unworked form as part of such a tribute. The early glass vessels from Thutmosis' reign were reflections of the highly sophisticated industry which was at its peak in Mesopotamia at the time.

The major Egyptian technique was the sand-core method, which involved covering a friable core with hot glass; in duplicating this technique the greatest difficulty has always been to get the hot glass to stick to the core initially. This presumes that it was always introduced hot. However, consistent with the Mesopotamian beakers and the sand-core vessels which have been found there, some were undoubtedly prepared cold and introduced to the heat to cause fluxing of the glass.

The earliest Egyptian sand-core vessels show examples which were probably produced by this method and help to establish the links with Mesopotamia.

The research carried out to date has suggested two methods of covering a sand core with an even layer of glass: **1** winding a soft rod of glass round a core (see figure 10), and **2** dipping a sand-core into molten glass and rotating it. I would not disagree that these methods were used, but I think that there was at least a third, and that this was probably the oldest and falls within the heat-formed category covered by this book. The principle is even closer to ceramic glazing techniques, from which glass is thought to have evolved.

This method involves a sand-core on a tapered metal rod (for removal). This turned profile is then covered with an amalgam of finely crushed glass and organic binders which will burn off on heating (see figure 11a). Finely crushed glasses existed as frits for glaze production and the ancient ceramicists were skilled in their composition. They could control both colour and the temperature at which glazes would flow. It would have been easy for them to produce an amalgam of glasses which would gel in the right way when heated.

The core, with its amalgam covering, would be rotated in a flame or small furnace, burning off the binders and fluxing the glasses to create a homogeneous skin (see figure 11b). The core and glass could then be pushed off into a lehr and when cold the sand removed from the interior.

I suggest this technique because certain ancient vessels, mostly single-colour, show a gritty, granular make up not explained by the other two methods (see figures 11c and d). Also the very earliest Mesopotamian vessels display a mosaic quality whereby small sections of cane are built over a core with finely crushed glass and binders, and then heated to fuse them. Some of the very earliest examples were fabricated without heat by placing cane sections into a bituminous base.

After the first flowering of glass in Mesopotamia and Egypt in the middle of the second millenium BC, glass seems to have gone into a decline only to re-emerge in both centres from about the ninth century onwards, but in a changed form. Glass was now seen and used as a material in its own right rather than as a mimic of others. Transparent glass became a concept for the first time, having been opaque and colourful before. It was used much more as a material from which to produce vessels. The vessel types were varied, and were evolved from precedents in stone and metal.

Clear bowls in imitation of gold originals began their production. They were possibly produced in the workshops of the Royal goldsmiths at Nimrud, which appears to have been the centre of their production. In one excavated workshop at Nimrud were found fragments of one hundred and forty hemispherical bowls of clear greenish, transparent purple and turquoise-blue glass. Most were cast and finished by lathe grinding, wheel cutting and engraving. The most famous examples are the Sargon vase and the Gordion omphalos.

The mastery of cane work which the Mesopotamian beakers illustrate was taken up and extended by the Egyptians. By using the basic technique of creating, through bundles of cane, cross-sections of pattern and stretching them, they made incredibly complex tiny rods which could be sawn, re-fused, and combined with other forms of glass to decorate rooms, furniture, statuary and jewellery.

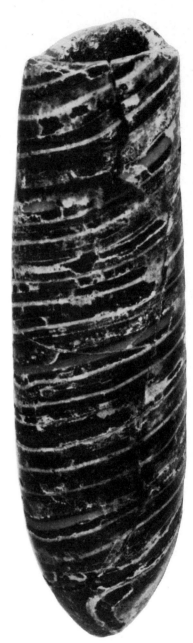

10 An alabastron, made by wrapping a multicoloured rod round a core.

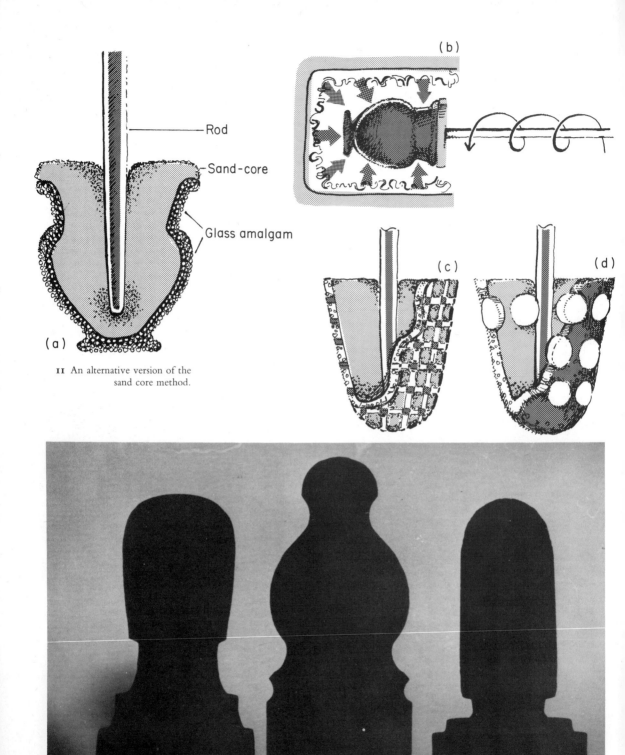

Rod

Sand-core

Glass amalgam

(a)

(b)

(c)

(d)

11 An alternative version of the
sand core method.

12a Sand cores made from resin-bonded sand and turned to shape on a lathe.

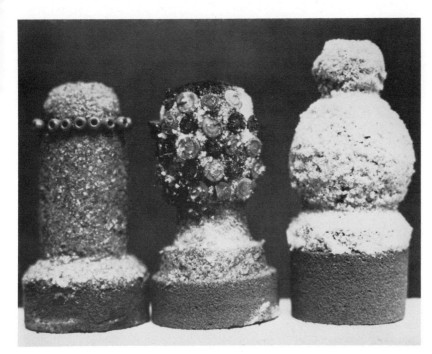

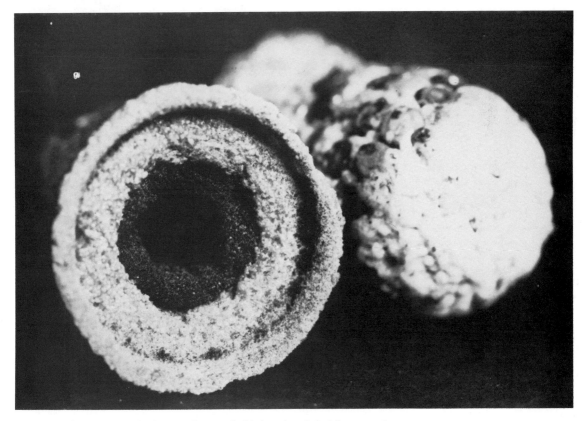

13 A detail of the rim area after heating, showing the blackened sand partially removed.

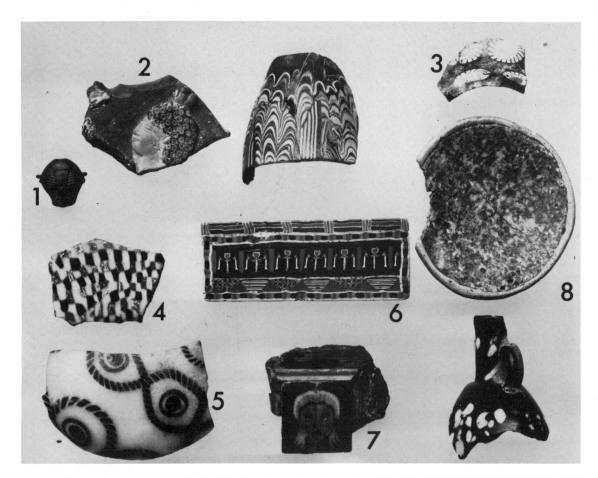

14 Egyptian glass fragments: (1) cast fragment, fused in a mould from crushed glass; (2) relief fragment, fused in a mould from crushed glass and cane sections; (3 and 4) sand core vessels made by embedding cane sections in crushed glass and fusing them; (5) bowl fragment in crushed glass with embedded cane sections and reticelli rods; (6 and 7) cane amalgams, kiln fusions of pulled rod sections sawn and polished for mosaic inlay work; (8) small bowl fused from crushed glass over a former within a retaining rim of cane.

15 A mosaic of pulled out cane bundles. Such miniaturised repetition could be achieved by a combination of rod pulling and kiln fusing.

Glassmaking in the Hellenistic period

Like all Egyptian art, glass served the elite priesthood; it was not therefore subject to normal economic pressures, and its makers were allowed to develop rich, varied, complex, and often time-consuming techniques to produce objects of small scale with no claim to practicality. The colonising of Egypt from the third century BC by first the Greeks and then the Romans added a new twist to this comfortable arrangement.

The Greeks and particularly the Romans valued rare and beautiful things in their own right irrespective of religious overtones. They used the varied skills within their Empires to satisfy their demand for desirable artefacts to use in a secular, domestic environment. Centres like Alexandria were encouraged to produce quantities of luxury objects which displayed the ingenuity and richness of indigenous glasswork, but in more acceptable forms. These pressures resulted eventually in the devaluation and disappearance of the ancient skills under the Romans, and it is rare to find anything of real quality by the third century AD. However, between the third century BC and the birth of Christ these pressures produced some magnificent new glass. These pressures were distinct from those which caused the invention of mass-produced blown glass three centuries later. It was a shift of attitude as well as use; during the Hellenistic and early Roman period glass was no longer a religio-mystical material but a luxury one – it retained some of its magic however.

The objects which have been chosen here to illustrate their types and handling methods were made at a number of places within the Greek and Roman Empires. Generally they utilised the characteristics and viscosity levels of glass observed and described by the Assyrians, recognising and, to a greater degree, exploiting the potential of the material to shape itself, given the right circumstances. They extended the vocabulary of the process of softening glass under different conditions, producing a range of possibilities which (though extended) have not significantly been added to since. The three hundred years before the birth of Christ were the golden age of glass forming, as far as surviving examples of glass show.

The largest category of objects remaining from this time are bowls, illustrating the new domestic requirements of the Greco-Roman world. Relative to previously produced objects, they are large, a diameter of 12cm (5 in) being average (figure 16). The technique of forming was a departure from the totally enclosed cast ciré-perdue versions, and employed the first and second stages of viscosity. Blank discs were formed, either at source by ladling or crucible pouring in the case of single-colour transparent forms, or by kiln-fusing rods together to produce the patterned versions. These blanks were sagged under their own weight over, into or through a former (figure 17).

Finishing was now restricted to fettling up the marked surfaces, and trimming rims. Only the areas which had been in contact with a former whilst in the kiln were treated, rather than the whole bowl being given a new surface. In the case of a bowl formed over a former (figure 18), the inside would be lathe ground and the outside fire-polished as it left the kiln.

Single colour bowls with plain surfaces

These simple bowls with elegant sections were luxury items, relying on their colour to offset their simplicity. They occur in rich deep shades of amber, green or purple. New sites are being uncovered which tell us more about these objects. A typical site recently excavated revealed five hundred rims of different vessels, and four hundred fragments of vessel bodies. Profile classification

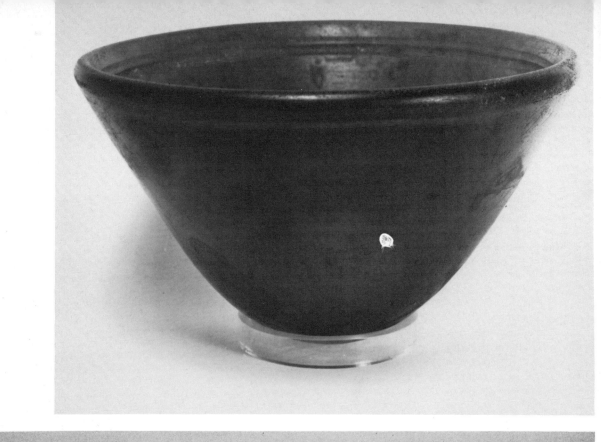

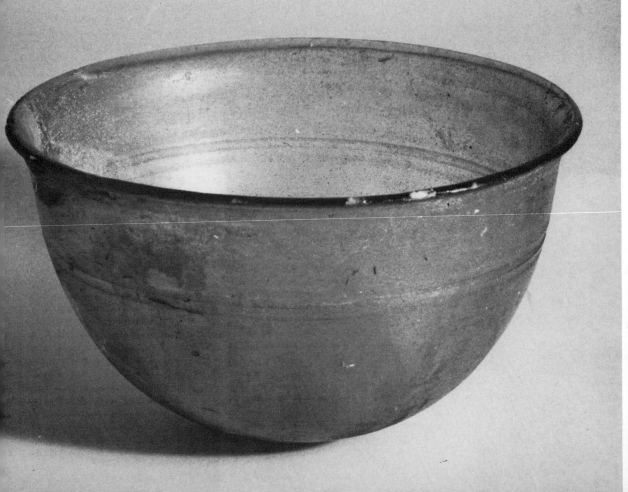

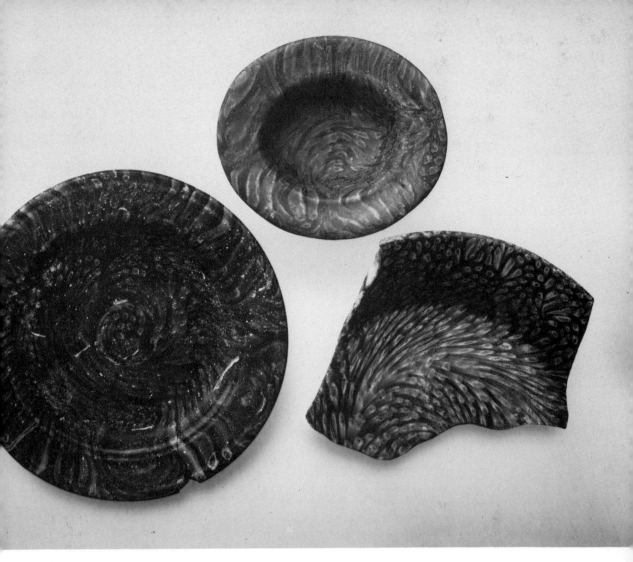

indicates that all were sagged over a former, the outside surfaces being fire-polished and the interiors ground. The rims are sometimes fire-polished and sometimes ground, indicating that they were cleaned up only when they distorted too much. Many have horizontal grooves lathe-ground on their interior, this is a characteristic of metal bowls of similar form and on which they are based. These sites, which date from about the fourth century BC, generally lack any evidence of glass-furnaces, which suggests that the disc blanks were made elsewhere. Frederick Schuler in his articles has put forward a ciré-perdue blanket technique for all pre-Christian single colour bowls, it can be seen however that is only really applicable to the Achaenid goldsmiths' bowls.

The interesting point about sagging is that it mirrors another metal forming technique, that of forming or 'raising' a metal blank with a hammer over a mandrel. In the case of glass, heat, viscosity and gravity take the place of the hammer. The profile sections of these bowls show a thickening toward the rim as the glass blank flows a little to cover the sometimes steep former. Mistakes have been found showing typical kiln forming faults like excessive thinness where too great a flow of material has occurred. Although they follow metal originals they use the language of glass to achieve this and are much more than mere transpositions of form from one material to another.

16 *Above opposite* A Hellenistic cast bowl (fourth century BC), sagged over a former from a disc blank, its rim and interior ground and polished to remove the forming irregularities and mould marking. The technique follows the metal precedent of 'raising' a blank of metal over a former with a hammer, with heat taking over the function of the hammer.

17 *Below opposite* A Hellenistic cast bowl (fourth century BC), also sagged over a former, but the thick blank has been ground inside and out to obtain a more elegant profile.

18 *Above* Three Roman bowls made from cane sections arranged within a disc fusing and then sagged into a former (see also figure 184).

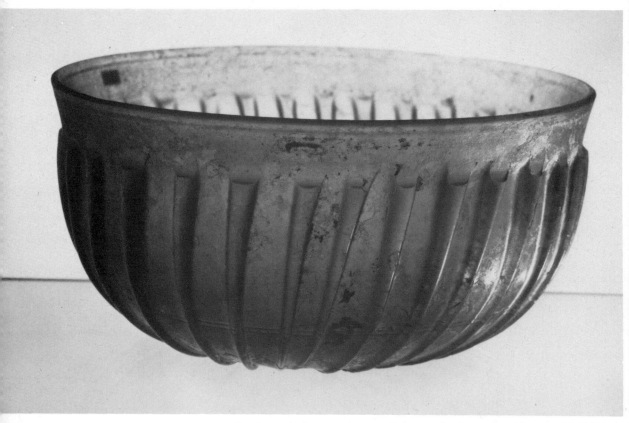

Bowls made by a variation of this method are the pillar-moulded bowls which are still accepted as being lost wax castings. The surfaces on the bowl are a subtle mix of fire-polished, pressed and ground finish which is one of their attractions (see figures 19 to 25). Again there are metal precedents in precious metals but the ribbing actually helps the disc to sag. (Figures 20 to 24 show the stages in the manufacture of a ribbed bowl). The bowls without ribs are generally deeper in section and have been formed at higher temperatures to allow the glass to run further.

Hemispherical and ribbed bowls appear to have been produced in fairly large numbers and support the notion that their sagging methods were an attempt to produce larger quantities of these objects than casting could. The workshops seem to have been separate entities, not self-contained in any sense, so that a bowl could have been formed in one workshop from a blank imported from another, and then ground and polished at another. This is true of cane, frit and ingots in addition to part-formed objects. The trading of ingots continued until the eighteenth century AD when round cakes of coloured glass were produced in Venice to supply enamellers all over Europe who ground them into fine powder. This basic difference of attitude between the glass blower and kiln worker is still very marked today, where the kiln worker buys raw material in sheet, rod or powder form to form in standard kilns.

19 A very fine Hellenistic bowl (third century BC to first century AD) in which the pressed, ground and fire-polished surfaces can be seen well.

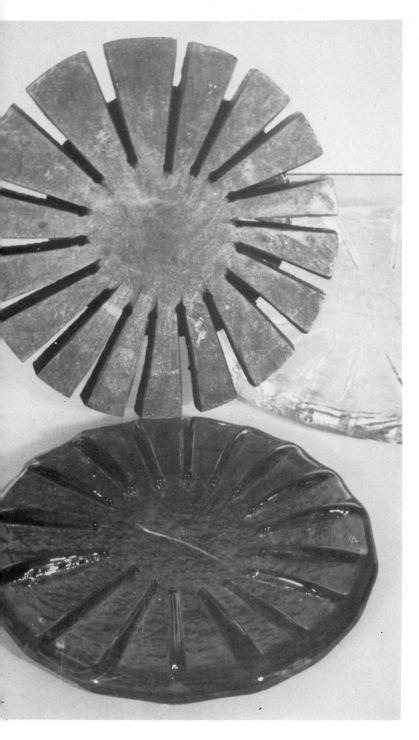

20 First stage in the manufacture of a ribbed bowl: a hot glass disc (crucible-poured) is pressed with a tool. The hot glass squeezes up into the gaps leaving fire-polished ribs on its surface.

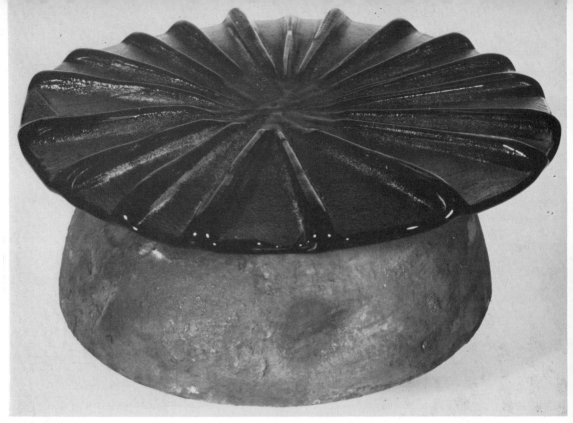

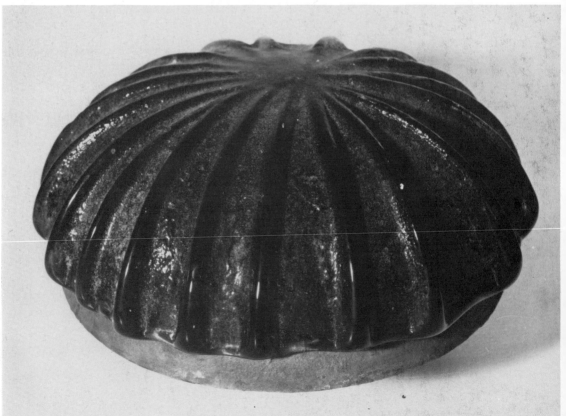

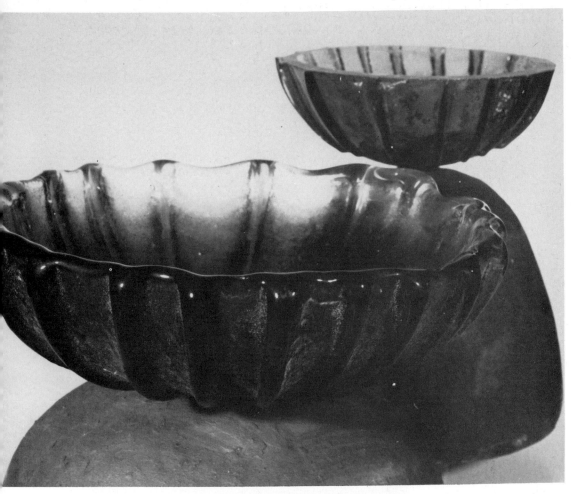

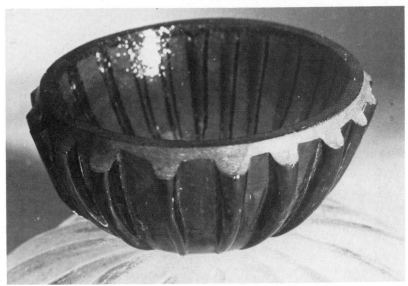

21 *Above opposite* Second stage: the cold disc is placed on a mould and heated.

22 *Below opposite* Third stage: the disc sags over the mould.

23 *Above* Fourth stage: the irregular rim of the formed bowl is flattened.

24 Fifth stage: the grinding of the rim is extended to include the ribs.

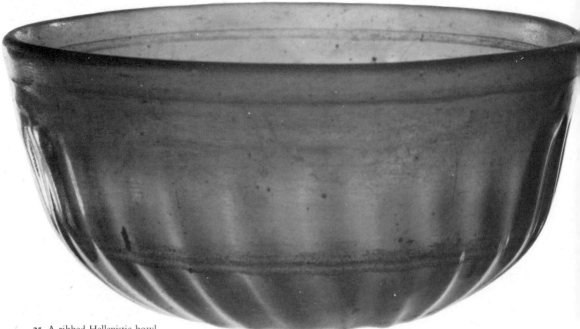

25 A ribbed Hellenistic bowl (third century BC.) about 5 cm (2 in) high. Its soft form suggests that it is a ribbed bowl which has been sagged twice, the second time to create a deeper form. The interior rim area has been ground.

Cane-sectioned vessels

These bowls have been the subject of more speculative methodology than any other ancient glass object. With their attractive jewel-like surfaces (figure 26) they reached their peak in Alexandria in the three centuries before Christ, and like the single colour and ribbed bowls take an Assyrian technique further. They are a response to the empire market for high-class luxury artefacts and they combined the richness of Egyptian cane inlays with the ubiquitous bowl form. There is no doubt that their function was decorative and precious, not practical.

Researchers have suggested a method for their manufacture which involves sections of cane placed in a mould with a second mould placed on top to hold them in position while the whole is fused to create a unity. There are many variations of cane-sectioned vessels, some of which could mainfestly *not* have been made in this way, and in my opinion none of them were. If they are studied as a group it appears that no one method was used for all types, and the true technology is richer and more varied than hitherto presumed.

They form a number of categories, but are essentially variations on a single technique. It is a two-part forming process, the first stage of which involves the production of a circular blank, which is then sagged over, into or through a former (figure 27). The first stage involves a higher temperature than the second, for the elements used (cane sections) are fused together so that each component softens to the point where it flows into its neighbour, analogous to welding fragments of metal together.

The components from which these bowls are fabricated are varied but they are all based on the simple self-coloured cane, of round or square section. These single coloured canes are used as long horizontal striped elements within a design or cut up as circles or lozenges of colour. They are used in their familiar

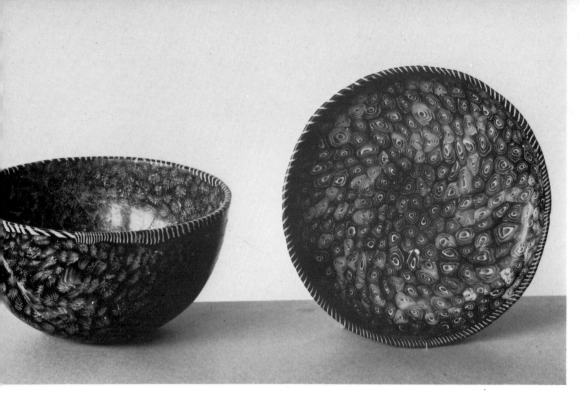

26 Roman cane-sectioned bowls.

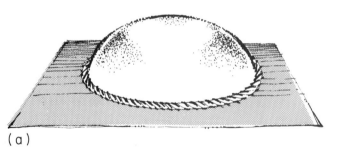

(a)

27 Stages in the production of a cane-sectioned bowl with a reticelli rim: (a) a reticelli (multi-cane) rod is lamp-formed to a similar diameter to that of the mould, (b) this cane is used as an accurate perimeter within which to fuse sawn cane sections to create a flat disc for sagging, (c) the disc is softened over a mould to create a bowl which is then finished by selective cutting and polishing.

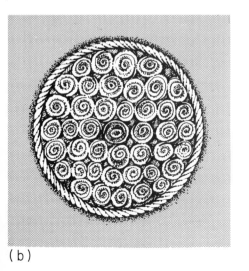

(b)

(c)

millefiore form, that is multicoloured cross sections created from bundles of canes heated and drawn out; these are sawn and used as pattern elements.

The third common elements consist of two canes which have been worked in a flame to soften and twist them together, making a twisted spiral of different colours (figure 28). These were used for making amulets, bracelets, loom weights, etc., (figure 29), or to form the rims of cane-sectioned bowls, and in their own right to form complete bowls, the delicate reticellis. In addition crushed glass is sometimes used to create the background to especially complex or pictorial cane work, very much in the Mesopotamian manner. A variation of this technique was used in the plaques of cane and crushed glass which were produced to decorate architecture or furniture (figures 30 and 31); they are very high quality objects which are more than just flat versions of the bowls.

A description of the production of one kind of cane-sectioned bowl is given in figure 27. The conventional explanation for the method of manufacture, involving an upper and lower mould, is unsatisfactory for a variety of reasons. It ignores the evidence of the stretching of individual cane segments which would, if they had been fired in two-part moulds, have been compressed. Usual explanations also ignore the twisted cane rims and examples which are fusions of cane lengths and sections (see figure 26).

The first step in their production has to be the twisted rod-section rim. This could have been made to correspond with the base diameter of the mould itself. Once made it would serve as the border within which to fuse cane segments into a flat disc. This disc would then be sagged over the former mould and the bowl

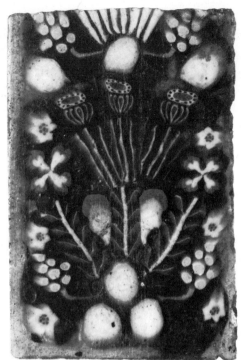

29 *Far left* This Roman loom weight is made from a twisted rod, the basic form for a number of types of artefact, including bracelets and reticelli bowls. They were also employed as rims for cane-sectioned vessels.

30 *Left* A Roman plaque made of a crushed glass and cane section amalgam.

31 *Below* The production of these small slabs of glass, which were used as parts of interior decoration, was carried out by methods similar to those used for early sand core vessels. Unlike cane-sectioned bowls, which are entirely fused from rod sections, these plaques comprise a main fabric of crushed glass into which cane sections of various complexities were fused. The drawing represents some of the rod sections with the crushed glass removed. It is a combination which allows a subtlety often missing in the more even textured bowls.

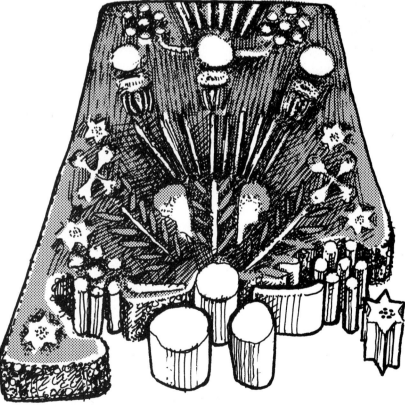

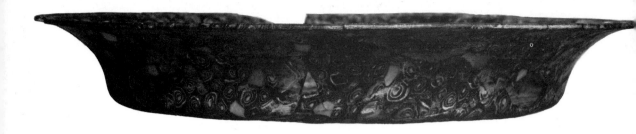

32 A shallow cane-sectioned Roman bowl – a fused blank sagged into a mould (possibly ceramic).

finished by cutting and polishing to remove irregularities. In figure 26 it can be seen how the rim has taken up the irregular sagging of the disc. Many of these bowls show evidence of being ground inside and around the rim area while the exterior is left fire-polished.

Within the overall classification of cane-sectioned bowls are obvious divisions of types of differing characteristics. The first and simplest group are the large shallow dishes.

They comprise a simple disc of internally patterned cane sections with no contrasting rim and are sagged into a shallow mould (figure 32). The depth of drop required from the glass was small and did not need a very high temperature. The majority of the dishes' surfaces are flat; as a result there is

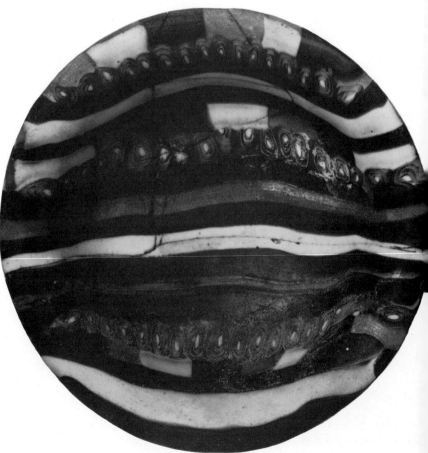

33 A Roman bowl made from cane lengths and sections fused to create a blank and then sagged over a former. The distortion of the straight canes demonstrates the way in which they were pushed apart by the former as they softened.

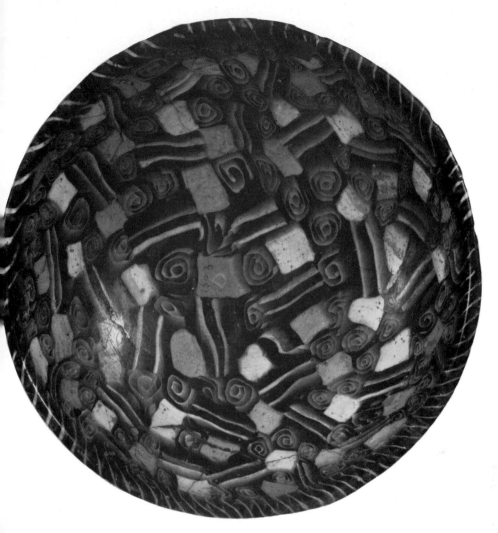

virtually no movement or flow within the disc and no distortion of the cane segments which is so much a feature of the other categories. As the disc is only taken to softening temperature in its forming operation, it does not reach a stage where it is sticky, and therefore the mould could be used many times. The process can be likened to lining a pie dish with a disc of soft rolled-out pastry, or press moulding ceramic dishes from a plaster mould. Because of their lower temperature forming they generally required less finishing and are less mould-marked on their undersurface, which is the area of mould contact. Altogether these dishes represent the most easily series-produced cane vessels. It is tempting to speculate that the moulds could have been thrown or press moulded ceramic dishes, which they so closely resemble in shape.

The next group are the hemispherical bowls (see figure 26) which, by definition, are deeper in profile and which have been formed at a higher temperature to achieve the higher level of distortion needed from the original disc. Putting it another way, some parts of the glass disc have further to travel than others. As a result the cane sections which are in the areas of greatest movement are greatly distorted. Where a bowl is made from equal sections to begin with, the distortions evident in the finished piece represent a kind of

34 A Roman bowl, interesting for its variety of section types. The rim is created by reticelli cane.

diagram of the forces exerted within the glass during shaping (see figure 26).

These bowls are shaped over a former. This is shown by these diagrams within the objects, in other words the stretching and distortion occur where you would expect with this method. This is best demonstrated in figure 33, where the horizontal canes have obviously been pushed aside as they have formed *over* a shape, if they had been sagged *into* a shape the stripes would have been pushed toward one another. Where such bowls have not been completely ground over their surface, the exterior is fire-polished; this is also consistent with this method.

The rims of many of these bowls (figure 34) are formed from twisted (reticelli) rods which must have been given their circular form in the flame. This circle of twisted rod provided an accurate perimeter for the disc fusing, and made fine relationship between the disc and the sag former possible.

These circles of twisted rods were also used to make a rare group of bowls which form another sub-category. They are formed from a number of circles of increasing diameters (see figures 35, 36 and 37). These circles would fit over a former and the bowl is therefore formed by fusing not sagging, the rods staying where they are positioned.

A number of reticelli circles are made of decreasing diameters to correspond with the slope of the mould (figure 35a). These are placed on the mould so that they form a complete covering of horizontal twisted bands (figure 35b). They are then fused in this position with minimum distortion (figure 35c). Heat is used to fix the form not create it, and in this way these bowls are different from other cane-fused vessels. The entire interior and exterior surfaces of these bowls were ground to remove the slight undulations caused by the rods which must have been evident after fusing.

The manufacture of the internally patterned canes by stretching hot bundles of coloured rod creates a by-product which was used in the production of

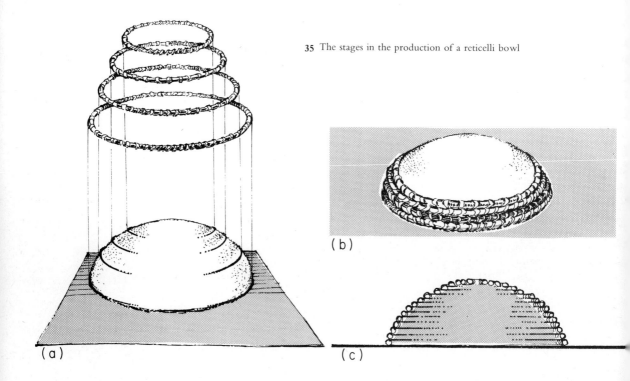

35 The stages in the production of a reticelli bowl

(b)

(a)

(c)

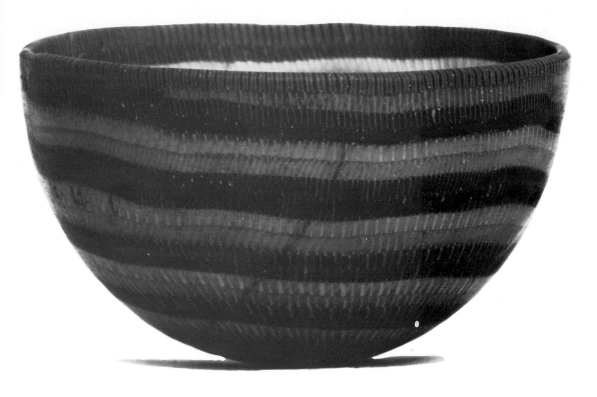

36 *Above* An Alexandrian reticelli bowl in which the different circles of twisted cane can be clearly seen – note the movement of the rods as they have settled during fusing. The finished piece has been ground inside and out removing any three-dimensional traces of the canes and giving the flattened zigzag effect which is characteristic of this kind of object.

37 A middle-eastern woven basket, a possible source for both form, pattern and technique of the glass version. High quality objects were often derived from more mundane artefacts.

38 Glass cane sections: when glass
canes are bundled, heated and
pulled out, a part of the original
bundle remains unstretched, and is
in contemporary cane production
discarded. In the ancient world
these 'cow horns', with a large
cross-section at one end and a
small cross-section at the other,
were used as raw materials for
further types of object (see also
figure 66).

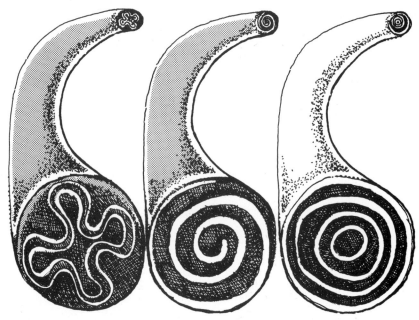

another type of bowl. When a sectioned (millefiore) cane is produced part of it remains as a heavy lump of the same diameter as the original bundle of canes (figure 38). This is the area nearest to the metal rod to which it was attached for stretching. This area is cooler and does not stretch. In modern cane production this lump is usually broken down to be re-used as cullet (see figure 66).

The ancient glassmakers used them as a source of larger patterns and used them by sawing thin sections from them to produce some high quality bowls of a very different character from the more conventional forms (figures 39, 40, 41).

These bowls are much more like natural stones with their layered striations and more arbitrary internal movements; this is in contrast to the prettier repetitive patterns of the cane-section bowls. They perhaps represent an echo of the original use of glass as an equivalent or imitation of natural stone. Otherwise their technique is the same as that for cane bowls generally.

39 Detail of a bowl made from heavy cane segments.

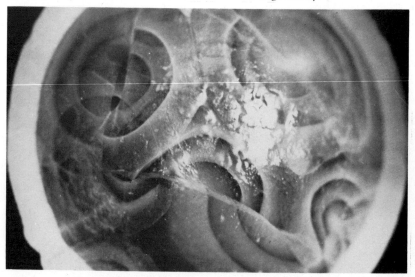

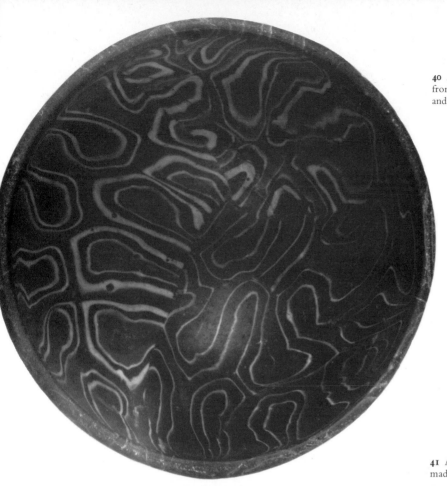

40 An Alexandrian bowl, made from heavy cane sections, fused and sagged.

41 Another Alexandrian bowl made from heavy cane sections.

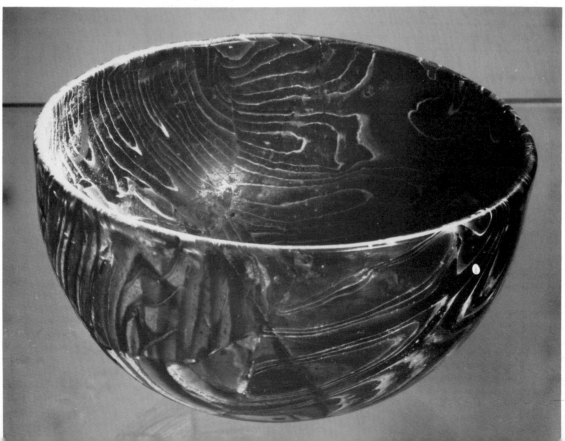

42 *Right* The creation of a basic block for carving.

43 *Below* A beautiful hybrid which mixes sand core and heat forming techniques.

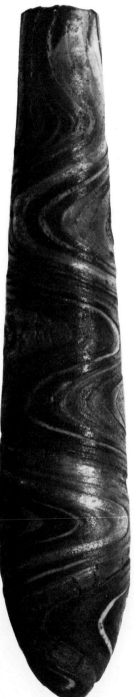

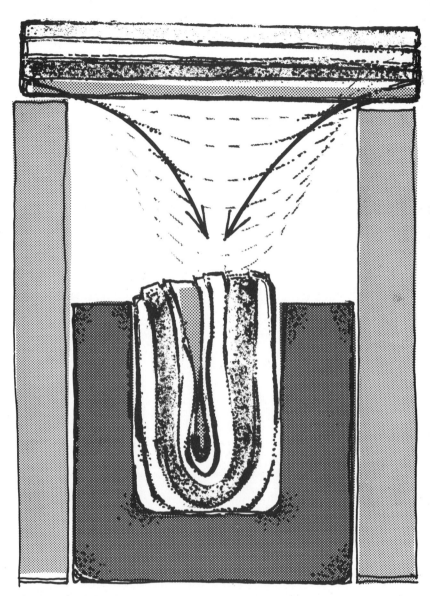

Vertical containers

This natural stone quality, which is basically layers of contrasting colours subject to distortion, is characteristic of another group of objects. Their characteristic colours are opaque white, purple, green, blue, clear with inclusions of gold leaf. Like their geological counterparts, they consist of bands of colour which are distorted, in this case by heat. Their forms are very different from the bowls, comprising small containers with a vertical emphasis: mainly small bottles, alabastra and pyxis.

Their techniques vary, but they all have a starting point in common, basic bands of contrasting glasses which are manipulated in different ways. These fused horizontal bands could have been made in a number of ways; either by fusing in a mould layers of contrasting rods to make a block which is subsequently sawn into thin sections or used solid, or by pouring from a

crucible which has been filled with a number of contrasting glass colours (see figure 136).

Such raw materials would be deformed in a kiln to make heavy blanks from which to lathe cut objects, in the strict lapidary tradition. Vessels had been carved from solid lumps of stone from the earliest times and pre-dated vessels in clay, glass and metal. Figure 42 shows one way in which glass was used to manufacture solid blanks with internal colour and movement to rival natural stones. A solid block would be supported horizontally over a mould at its extreme edges. On heating, the block would soften and fold down into the mould. On cooling this block could be lathe turned into a vessel.

The thinly cut sections were used to make the beautiful alabastra which are a mix of heat forming and sand-core skill manipulation, where the sections are added to a traditional sand-core object and distorted by rolling (figure 43). It has been noted that the interiors of these objects are very small and rough with a distinct vertical emphasis. This is consistent with this method, and calls into doubt any practical function to which these objects could be put other than ceremonial.

In production terms they are a mixture of techniques and stand halfway between heat forming and conventional glassmaking (figure 44). Their basic ingredients were: crushed glass, gold foil, blocks of horizontally banded glass, heat and skill. The initial banded blocks were kiln-fused from canes, cut into thin, identical longitudinal sections, placed hot onto a glassmaker's slab (marver), then picked up onto a hot sand core covered with a sticky layer of crushed glass and pieces of gold foil incorporated into it. The mass was then warmed to make it homogeneous and soft.

44 The stages in making an alabastron: (1) a banded block was made from fused canes and (2) sliced, then (3) the slices were placed on a hot slab; (4) the slices were picked up onto a sand core, warmed, then (5 and 6) rolled lengthways down a semicircular former; (7) the resulting surface was polished.

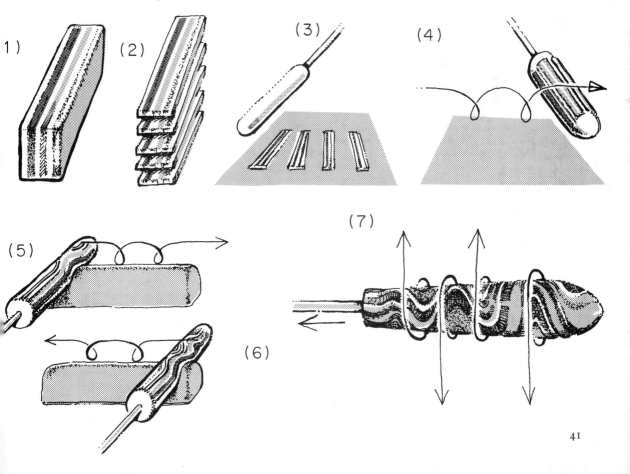

(1) (2) (3) (4)

(5) (6) (7)

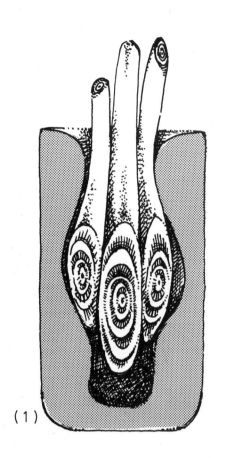
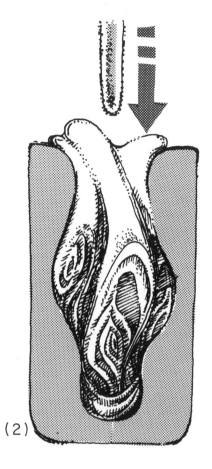
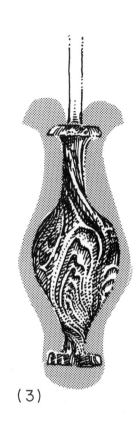

(1) (2) (3)

45 Forming a blank from irregular rod sections for lathe turning: (1) the sections were placed in a ceramic mould and heated until they deformed to fill the mould; (2) a metal rod was pushed down into the molten mass to displace the glass and create the small, vertical, scarred, interior space; (3) this rod could have been left in position while the glass cooled and used as an aid in lathe-turning the final vessel.

It was then rotated along a semicircular former, first in one direction then the other, carefully down the length of the object. This had the effect of pushing the horizontal bands in alternating directions. The result, when removed from its rod would be polished. The finished alabastron, with the gold foil glinting through the distorted layers, mirrors the geological stresses found in natural stone without copying.

A rare group of objects form yet another hybrid and consist of a handful of small flasks which are made from the heavy sections of multilayer canes (figure 45). The canes appear to have been fused into blocks, with, at some stage, a rod pushed into the soft glass to make a rudimentary interior space and to squeeze the soft glass well into the mould. These blanks were then completely lathe-turned to give them their form.

This group is rare and, more important, of a very high quality (figure 46). Nothing seems to have been lost of the original precious quality of this kind of work. The nearest analogy of their value and function is to the group of scent-bottles produced in the mid nineteenth century in Bohemia and prized by the Victorians.

Our concept of glass is dominated by a presumption that it is more often than not transparent if not colourless. It is hard to realise that this ideal did not really manifest itself until after the invention of blowing, and that prior to this it was rarely translucent. During the three centuries before Christ it certainly became technically possible to produce clear glass, and it was increasingly used, but only

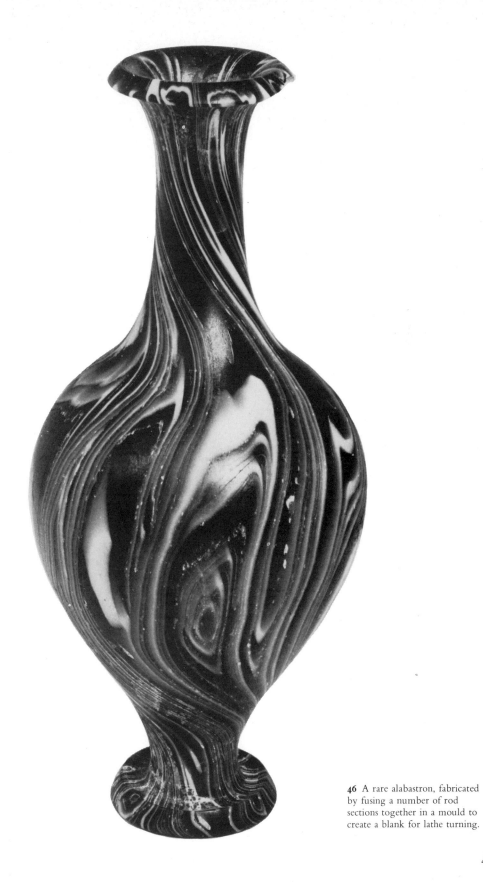

46 A rare alabastron, fabricated by fusing a number of rod sections together in a mould to create a blank for lathe turning.

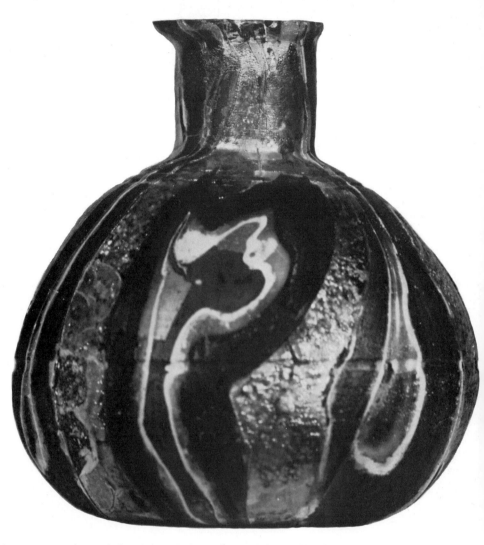

47 A Roman flask, about 5 cm (2 in) high, made by adding kiln formed elements to a blown form – an attempt to speed up production of this type of ware.

to extend the range of glass as a material, and not to supersede coloured and opaque glass. Clear glass was used to great advantage in the double-shell, gold-sandwich vessels, where a layer of gold foil decoration is trapped between two perfectly fitting bowls. It is difficult to speculate with any accuracy on their production methods, but they certainly involved sagging blanks over and into moulds and with such a degree of lapidary finishing that traces of this have been removed.

The Roman Empire caused both the development of blowing and the fairly swift decline of heat-forming. It is true that objects like cane bowls were still produced into the second century AD, but they were of inferior quality, and had degenerated as a result of market pressures from luxury to novelty ware (figure 47). There are famous references to rooms lined with glass tiles and these seem to have taken a number of different forms.

The gold-sandwich technique was easily adapted from the time-consuming three-dimensional version to the production of simple tiles with a gold leaf pattern trapped between two layers of clear glass fused together (figure 48). These were set into plaster walls to reflect light, and must have been very

effective in series. These tiles, suited as they were to the luxury Roman market, continued well into the Christian era. Another use of glass in architectural tiles is closer to pre-Christian mosaic and forms a link between ancient and medieval mosaic work. These tiles are of a castable, plaster-like substance, into which are set pieces of glass which have been cast, cut and polished (figure 49).

The fragments of glass give the impression of having been cast from powdered glass in some cases and poured from crucibles in others. They are very close in appearance to the mosaic tesserae of Byzantine mosaic work. They were used to decorate walls using reflected light. These tiles represent a continuation of ancient glass methods into the modern world, albeit a slight one. There are other echoes of ancient techniques less significant but worth mentioning. Pillar-moulded bowls continued to be made until the second century AD, but were copied in blown glass versions and died out. Cane-sectioned bowls were imitated in a rare series of pressed objects.

Although they were single colour, these objects have pressed into their surface the honeycomb pattern which fused canes produce (figure 50). There are examples of dishes and bowls made by the same method, which was to press

48 A gold leaf tile (early Christian period), with a gold leaf pattern fused between two sheets of glass, used for wall or floor decoration.

45

49 A wall mosaic section (early Christian period), showing a variety of kiln fused sections set into a plaster shape.

the pattern into a disc of soft glass and to sag this disc over a former, possibly as part of the same operation. However, glass-blowing became established as the major glass production method, a dominance which remained unchallenged until the second half of the nineteenth century. The glass techniques of the ancient world had been found to be unsuitable to satisfy the commercial world of the Romans and the societies which came after them for two millenia.

The Renaissance in Western Europe was the result of a shift of ideas; and the

re-examination of classical culture was because the new ideas resembled the old. In the same way our ideas about art, craft and material have changed radically during the past century to a point where we now have perhaps more in common with the art of the distant past than with our own direct ancestors. The techniques and attitudes of the Ancient World are not an exact match for our changed circumstances, but they can provide a useful set of standards, ideals and inspiration, and that is more than enough.

50 A large pressed Roman dish (second century AD): echoes of cane patterns derived from earlier fused sectioned bowls provide the basis for this hybrid.

51 Casting optical glass from a platinum pot (1955). The creation of 'one-off' specials, in this case pure optical blanks, has necessitated a return to the methods of the eighteenth century.

Flat glass manufacture in the 18th and 19th centuries

The dominance of blowing as a glass forming method was well established by the first century AD and remained unchallenged until the eighteenth century. This meant that much of the vocabulary of viscosity established and documented by the ancient workers was forgotten.

At the beginning of the Industrial Revolution there were some developments in the early plate glass industry which re-established aspects of glass not dominated by blowing.

It is well documented elsewhere that from Roman times sheet glass for architecture was produced by handicraft methods utilising the blowing iron and its attendant skills. The two main methods were: (a) crown, spinning an amount of molten glass centred on an iron out by centrifugal force to create as large a disc as possible, and (b) muff, an open-ended blown cylinder which was subsequently flattened to create a sheet.

These methods remained without rivals until the eighteenth century except for Venetian mirror manufacture, where hot glass was ladled into moulds to make rough-cast sheets of glass which were painstakingly hand ground to give them a polished surface. Mirrors produced by this method were limited in size and quite amazingly expensive. Even the muff and crown methods only produced small irregular panes of glass which severely limited the design of windows as architectural elements. Despite this they continued into the nineteenth century; Chance Brothers of West Bromwich produced one million

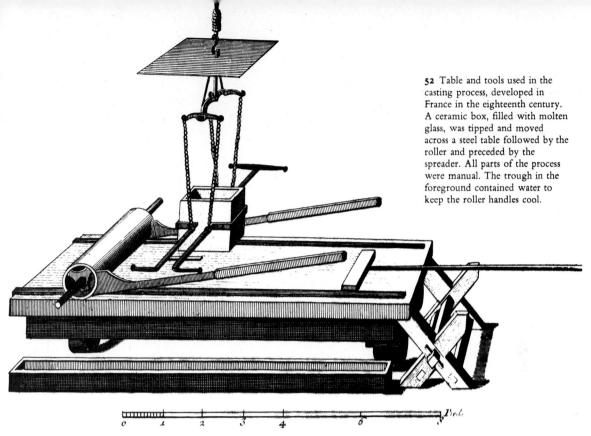

52 Table and tools used in the casting process, developed in France in the eighteenth century. A ceramic box, filled with molten glass, was tipped and moved across a steel table followed by the roller and preceded by the spreader. All parts of the process were manual. The trough in the foreground contained water to keep the roller handles cool.

square feet of muff glass for the Crystal Palace in 1851. Glass factories often combined the production of bottle and window glass.

The first experiments into alternative flat glass manufacturing methods were given their impetus by the crippling cost of the mirrors used in Louis XIV's palace at Versailles. He inaugurated a Royal Glass factory (which now exists as St Gobain) to establish a better and therefore cheaper source of supply. By isolating flat glass production from the general article, blowing factory, they made it possible to adopt a fresh and specific approach. These early experiments were to develop into large industrial concerns but initially the small amounts required for Royal use meant that a small intense unit was set up. It is interesting that when the glazing of the Sydney Opera House called for limited amounts of a special colour glass, a French factory went back to eighteenth-century methods to make it.

The main bonus of being able to study the problem in isolation meant that they did not have to begin from a premise of hand manipulated skills, but could approach glass from an engineering standpoint as a material with certain exploitable qualities.

Their first move was to replace ladles with larger ceramic boxes and to fill these from the glass pots. The hot glass was poured from these boxes onto a metal table and spread flat (figure 52). These sheets were simply larger versions of the Venetian rough cast mirror blanks, but the essential step had been taken.

The really creative move came with the development of a ceramic box with a slit along its base through which glass would pour as a continuous sheet as it was moved across a metal table. This seems to me to be a real use of the physical properties of hot glass harnessed to a definite requirement. Once this simple process had been established it was soon added to. Most of the major processes involving flat glass manufacture in the nineteenth century took as their starting point the sheet of glass created by pouring liquid glass through a slit or over a

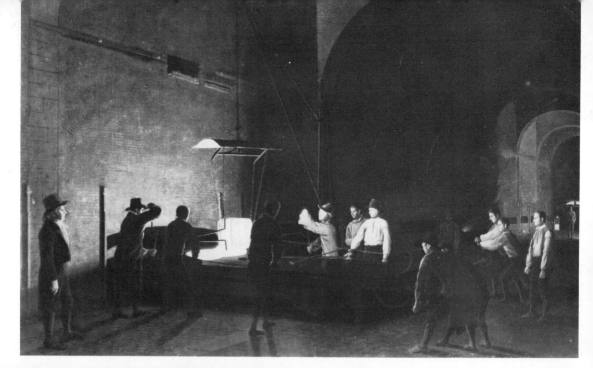

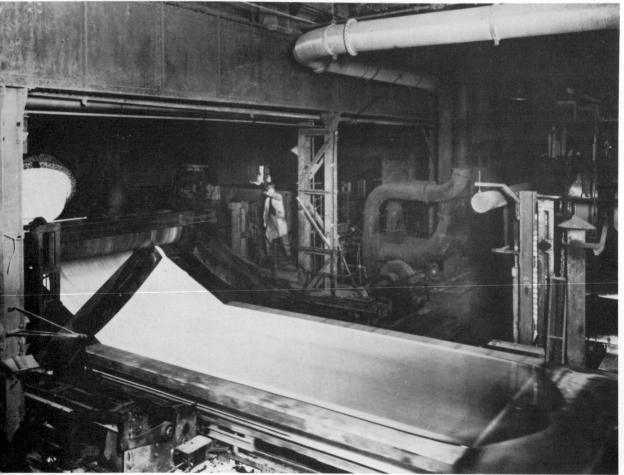

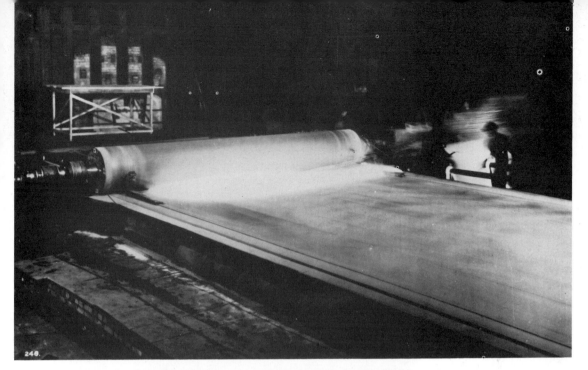

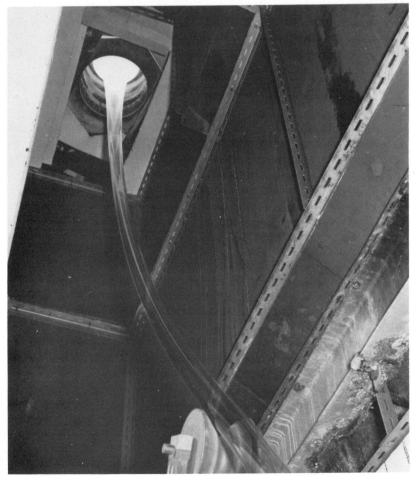

53 *Above opposite* The casting process used to make plate glass *c*1812, using the apparatus in the previous illustration, at the British Plate Glass Company's factory at Ravenhead, Lancashire. (The painting is attributed to Joseph Wright of Derby.)

54 *Below opposite* The Bicheroux method used from the 1920s to 1958 was an interesting glass plate method which exploited (a) the pouring quality of glass by tipping a pot of glass through fixed rollers, and (b) the stretching quality of glass. Once the molten glass was poured between the rollers, the table moved forward, stretching the viscous sheet into a drawn out ribbon.

55 *Above* In the nineteenth-century plate glass process, a heavy roller was pulled across molten glass, squeezing it flat as it travelled.

56 The Vello drawn process for glass tubing uses the various viscosity levels of glass to pull continuous glass tube from a stock of molten glass.

57 A rolled pattern of the 1930s, showing the stylistic range which the easier roller change and less automated process made possible.

ledge. Hot glass is a liquid, but one which has a heavy skin at its junction with the air, a property which allows it to be cut with shears, stretched on a moving table or squeezed between rollers, all alien activities for a true liquid. These properties allied to the poured sheet of liquid glass were rationalised into a number of ingenious processes, machines and types of flat glass, including patterned sheet glass. These processes were, like many heat-formed actions, highly visual as the photographs show; this is in contrast with more recent processes.

It may seem something of a paradox that I am spending some time explaining, and extolling processes which resulted in mechanised systems which make glass blowing seem archaic. It is not so much a paradox as an analogy. In my opinion the early experimenters used a language of glass which is totally compatible with the use of glass in the pre-Roman world and which our own use of glass as a medium echoes. For these reasons alone I feel that it is justified to claim these people and their devices as part of heat forming's ancestry even though the function of their end product is different from our own.

It is worth noting that the development of the flat glass industry from the eighteenth century to the present day has seen a gradual loss of flexibility as the industry has become larger. It was still possible in the 1930s to produce a wide variety of exciting stylish patterns for domestic interior use (figure 57). It was economic with the slower machines in use then to have small production runs, made possible by the lower cost of rollers and the speed with which these could be changed.

Even the early experiments in wired glass had a quality which is missing in the bland, mass-produced version (figure 59). The point being made is that large concerns like Pilkingtons or Corning produce enormous quantities of one particular kind of sophisticated product, and that their innovations are on a different level from the physically and visually organised processes under discussion. Current developments like photochromic colouring and ion patterning are highly scientific processes which can only be carried out by huge companies. My point is that the ground which they travelled in the eighteenth

58 A patterned roller from the 1930s.

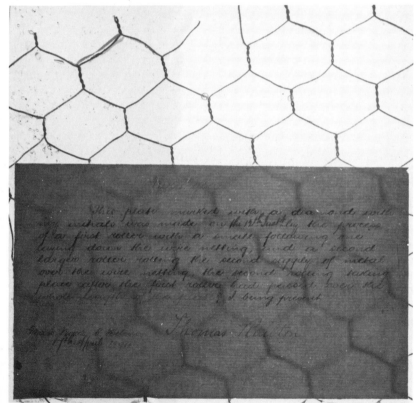

59 Wired glass, 1894: the first experimental application of wire netting to hot, rolled glass made by Thomas Railton, signed by him on the glass and described by him on the paper stuck onto the sample. This was a small scale hand–manipulated experiment which became rationalised into continuous machine production.

and nineteenth centuries is rich for those of us fortunate enough to be able to think about glass as a one-off or limited edition material.

There have emerged in the past few years, particularly in America, small production units making sheet glass by similar techniques and under similar conditions to the eighteenth century flat glass pioneers. Their aims however are different. They produce a range of small irregular sheets of glass, mostly by hand roller which are manifestly process orientated and with the physical evidence of that process visually present in the glass (figure 60). The uses to which these panes are put are mainly architectural but at the other end of the scale to the products of the multi-national companies. They are mainly used to make one-off products, decorative screens, glass panels and windows.

It may be that it is the very industrial sophistication of the large companies which make the artistic use of glass possible. It is no accident that two of the finest glass museums in the world are sponsored within the two giants of the flat glass industry, Pilkingtons and Corning. It is certainly true that their history is a source of inspiration to us.

A recent critic of the twentieth-century art glass movement complained that it was wrong for glass artists to look for inspiration only from other contemporary glass artists, for this resulted in limited, mediocre work. I would not disagree with this criticism, but enlarge it by saying that to look backwards at the history of glass is a way of enriching contemporary work.

Ruskin said that to teach artists the history of art made no more sense than to teach surgeons the history of surgery. Today we have perhaps arrived at a point where only by the study of history and its methods can we comprehend the present. It is in fact current practice in some medical schools to teach the history of surgery to medical students. The study of history is not now a Victorian eclectic search for motifs and models but a dismembering of great developments to expose the creative thinking behind their production and by emulating that rather than the object relate historical precedents to contemporary problems.

The diversification of glassmaking

Before moving on to the second part of the book which deals with the practical 'how' of kiln working, it is necessary to place present day practice into context. We have already seen antecedents of current work in the two millennia BC and acknowledge that, underlying our recognition and use of similar techniques is a similarity of attitude which is itself an amalgam of many pressures. This chapter explores some of the influences and indicates some of the parameters within which glass is now used as an expressive and educational material.

Glass methods underwent a dramatic change with the development of blowing, and attitudes toward it as a material turned around as completely. It became a material which was worked centrally in factories and from which was manufactured speedily produced containers to serve the imperial empire. Glass blowing replaced the forming methods of the Ancient world as effectively as the factories and serial production methods replaced the individual specialist workshops and their exclusive objects. The expressive, one-off art glass objects produced between the first century AD and 1800 were made within the factory system and from a firmly based tradition of skill-orientated blown glass, and with a repertoire of functional forms. The dominance of factory, container form, and glass blowing has only been seriously challenged within the last 100 years.

Having undergone its own industrial revolution in Roman times, glass was ill equipped to meet the nineteenth century version. In 1800 the factories based on the Roman model, with groups of glassmakers working pots of molten glass with blowpipes, were the centres in which were produced a wide variety of practical and decorative glass objects. Drinking vessels of all kinds from simple ale-house glasses to complex ranges of high quality table glass for the upper middle classes; bottles, storage and pouring vessels, chemical and scientific glassware, window and mirror glass. During the nineteenth century each of these functions of glass came under scrutiny by the industrialists, and separate industries were set up to produce a specialist kind of glass object with unique machinery and production methods. In this way the sheet glass and bottle industries came into being. The new technique of pressing had an impact as strong as glass blowing had on the ancient world by speeding and simplifying production. New technologies like gas and electric light made chandelier and oil lamp production redundant. By the 1870s glass made within the traditional format of hand production factory units centred around pots of molten glass and using Roman tools and skills had narrowed down to three types: lighting, prestige tableware, and decorative items.

Glass components for lighting developed as a specific response to the invention of electric light and gas (early electric light bulbs were mouth blown until their quantities merited the invention of a machine for their production). The equation of production costs, speed and market number requirements have remained stable enough to sustain a number of such factories to the present day.

In the realm of prestige tableware, the last remnant of the eighty or so hand-production factories active in Britain in 1810 are the handful still producing the only type of container which cannot be more efficiently produced by machine, of which the wine glass and decanter are the prime examples. Practical value and use is outweighed by symbolic value in terms of prestige. A virtue is made of skilled hand production, traditional forms, decoration and its lead crystal material. The other types of mouth-blown container which formed the bulk of the pyramid of which it was the apogee are now produced by totally automatic machine methods. As a result it rests on a base of static tradition.

In the field of ornamental items, glass has always had a decorative element, but it was not until the third quarter of the nineteenth century, when the market requirements of novelty were added to the challenge of mechanisation and undermined the practical function of hand-made glass, that decorative glass in its own right began. The last twenty-five years of the century saw a great creative upsurge in colour, shape, decorative effects, trade names and styles. All this went together to produce objects with no other claim to existence than that they were expected to be 'thought beautiful' rather than 'known to be useful'. The vase, which was once a subservient form to a display of flowers, became a flower in its own right.

The prime importance of this development of decorative glass was that it was only a short trip from there to art glass. It is significant that the two great glass artists of the late nineteenth century, Tiffany and Gallé, both worked within factories which produced decorative ware, and both produced one-off art works. These exclusive productions were subsidised by the more repetitive products of their establishments. Gallé and Tiffany within their respective circles created around themselves atmospheres of enquiry and innovation in glass on the highest possible level. In addition to the new direction and impetus which they gave glass blowing, they both initiated experiments into new techniques. In their prestige, one-off and limited series products, they used methods which were time consuming and uneconomic in normal factory terms. In other words they brought glass out of the Industrial Revolution which had decimated its reasons for existence, and set it on a new course.

It is interesting that both of them were influenced by their contacts with ancient glass, Gallé by his studies at the Victoria and Albert Museum in London and Tiffany by his observation of Roman glass with its iridescent patina. The important point was that they first revived the ancient attitudes to glass, by treating it as an expressive, precious, one-off medium, and this led them to examine the ancient techniques which this stance made possible. Gallé used blowing and glass-house manipulation as a starting point from which to make the 'raw material' blanks for his carved and etched final products. Both he and Tiffany used cane-work amalgams and small fusings which were introduced into the surface of their blown objects (see figure 174).

In economic terms their best work was expensive, complex and time consuming, and was made possible only by the series production and sale of cheaper factory versions which subsidised them.

The general atmosphere which surrounded these two was part of a larger re-definition of factory-based, hand production in general. Throughout industry, traditional, manipulative skills were, where possible, rationalised into auto-matic or semi-automatic processes. The residue of skilled, hand production has found a place in the twentieth-century industrial context only as a repository of perpetual traditional forms and hallowed values.

The energy generated by the great figures of the Art and Crafts movement, Morris, Ruskin, Dresser etc., fed two very distinct lines of development which

resulted in, on the one hand, the industrial designer wielding abstract organisational skills, and on the other, the artist craftsmen working ancient materials by ancient methods but outside the format of manufacturing industries. The role of artist/craftsman had been sponsored by many nineteenth-century factories as a method of generating new ideas and techniques to feed the production lines and their constant search for novelty.

In the British factories of the Stourbridge area, the employment of people like John Northwood and Frederick Carder resulted in developments like the rebirth of cameo glass, the exciting forms of matsunoke ware, and new techniques like silveria and electro-deposition. The production of many of these objects was not economic, but their development served to spearhead the decorative output of the factories. They also provided the one-off specials for exhibition and the numerous international expositions which dominated the end of the century. This in turn helped to focus the public's attention on named designers and artists, something which had happened rarely since Ennion 1800 years previously. Magnificent though blown glass was during its 1900 year dominance, its great objects were seldom the result of one man's creativity but rather, complex interactions of tradition, skill, material, style etc., and it was therefore something of a revolution for it to share the creator/object relationship which other forms of art had enjoyed for millennia.

The notion of studio rather than factory production began in ceramics, but by the turn of the century there were a number of individuals investigating glass as a medium rather than as a material. Many of these investigations involved glass techniques and methods unused since Roman times. The pâte-de-verre objects of Argy-Rousseau, Decorchemont and Walter, the wide range of ancient processes redeveloped or initiated by Frederick Carder, all contributed to the rennaissance of pre-blown glass.

In the early twentieth century the excitement of the Ecole de Nancy and its era died with the great characters who had sustained it. The notable exceptions were Lalique and Marinot, neither of whom embraced kiln forming as a method of working glass but were nevertheless founder members of the art-glass movement. Ceramics began to play a large part in America's cultural development and has created a strong enquiring place for itself in the post-war years. It was as part of this clay-work movement that glass was introduced in the early 1960s by Erwin Eisch, Harvey Littleton and Dominic Labino. Since then glass has established itself as a medium in its own right world wide. The initial interest was held by hot-glass worked from small tanks by traditional methods, but using largely sculptural vocabulary. This has been christened studio-glass and is a direct equivalent of studio ceramics with the accent being on a direct feedback dialogue between material and manipulator. As the movement has developed, however, a realisation has begun of the full range and potential of glass.

This brings us by a tenuous but genuine route to the position of glass as a material within an art context as it stands today. Much art activity cannot be discussed without reference to art education which sustains much of it. Glass has a place within both.

As an art medium glass possesses properties of light transmission, refraction, reflection, transparency, colour and surface variety. It has always seemed to me unfortunate that glass has only been employed rarely by mainstream fine artists and then in industrial, bland forms e.g. Duchamp, Larry Bell. As a craft material, its main exponents have emphasised its looser connotations, producing objects which refer formally to functional families – goblets, bottles, plates, etc. – or to well established sculptural precedents (Brancusi seems to have

suffered most). It has achieved this without actually contributing a great deal to either the decorative arts or serious sculpture. One of the main difficulties has been that the prime method of forming glass has been through the skill of glass blowing, a skill which requires a large investment of time to master even its basics. Add to this the fact that the vocabulary and tradition of blown glass is centred round container forms and their centrifugal geometry, and the equation becomes really too limited to allow a full range of expressive possibilities.

The range of kiln techniques opens up a wide and unbiased vocabulary of form, colour and texture which is manipulated not by hard won manual skills but by a number of proxy methods, most of which are part of a sculptor's basic skills. I have already mentioned that in the Ancient world glass was worked and used by goldsmiths, mosaicists and lapidary workers. These held much in common technically, and the mystique which grew to surround glass stemmed from its early associations with precious metals and precious stones. Throughout its history glass has always been surrounded by mystery, often deliberately so, much of it related to technical secrets. Much discussion of glass objects has been dominated by technical aspects to the detriment of more universal values. Glass is a unique material, but if this fact is used to protect it from evaluative criteria, it can only be counter productive in the long run. Glass like any specialist material benefits from regular confrontations with other expertises and beliefs.

Kiln working offers the opportunity to work glass within existing ceramic facilities with a minimum of adaptation, and therefore makes it into a more generally accessible material to designers, craftsmen and artists. In this way the mystery of glass will be dispelled, but the magic will still be there. Glass is too important to be restricted to specialist application. In terms of its use within education its wide range of forming methods and their visual monitoring make it ideal for developing a creative, experimental approach to materials in general. In this case glass is used not as a creative medium but as a tool, through which students can learn a particular kind of skill. This involves the learning of abstract design skills through experiencing a material rather than designing objects to be made from it.

This is a principle derived from the Bauhaus and which permeates much of early twentieth century theory (the work and writings of architect Frank Lloyd Wright for one), but because of its mysterious processes glass has not been part of these principles and has not taken its place alongside wood, metal, plastic etc., in the educative programme of artists, designers, and architects. As a result they lose out on two points. By not being exposed to glass they lose the lessons it could teach them, this then compounds itself by leaving them ignorant of it as a material to use in the practice of their professions. When glass is taught, it is necessarily within the restrictive framework of a technique designated as a craft, e.g. glass blowing or stained glass, and the result is that glass is only accessible as part of such a full-time commitment. The ensuing pages are intended to make this a little less inevitable.

The principles of
kiln forming

A glass blower uses his physical, manipulative skills to form the molten liquid. He uses tools which are extensions of his hands and lungs to control the glass by direct dialogue with it. The glass is never inert; that is why glass blowing is such an enjoyable activity to watch. There is immediate feedback from the material to the craftsman. In contrast the kiln former performs all of his controls by proxy and over an extended time-scale. He has no physical contact with his material and has therefore no skills to learn and wield. It follows from this that the works produced by kiln methods are different in kind from those produced by blowing. They have no direct physical relationship with their maker, they do not bear his handwriting in their forms and on their surfaces. It follows that different parts of the human intellect are used in their production; kiln-formed glass relates to blown glass in exactly the same way that printmaking relates to painting, the one is direct the other indirect. Each activity attracts different kinds of practitioners.

We have already established that, on heating, glass goes through progressive viscosity changes and that this viscosity can be used in relation to moulds, formers etc., to produce certain forms. You can never force glass to behave in a certain way, at best you can encourage it to do so. This book is about utilising the behaviour of glass under specific conditions as a major partner in the creative act of forming. Deforming glass by kiln methods presents a unique set of barriers to explore creatively and an equally unique vocabulary to utilise. The kinds of skill used are abstract, based on observation and prediction. The limitations experienced are those of inventive thought in relation to the material and its behaviour. The designer's creativity is served by his ability to effectively predict that behaviour under certain specified conditions and, by repeating those conditions, repeat the form. It follows that extensions of those conditions create extensions of the form, and this is how ideas are developed.

The feedback from material to worker is present, just as with blowing, but it is restricted to the period between taking a piece out of a kiln and loading it for the next firing. A glass blower's creativity is restricted by the level to which his skill has developed; in the same way a kiln user is restricted by the predictive control which he exerts. The glass-forming equation therefore constitutes (1) the basic glass properties, (2) heat, (3) raw glass, (4) constraints (moulds and other kiln equipment), but we can also add the most crucial now, (5) the overall control of these four by the designer using experience, creativity and aesthetic judgement to determine the path of the glass and select the desired end product.

It is worth examining the creative aspect prior to introducing the practical processes. It is the quality of the artist who determines the quality of the end result, for no matter how unusual the process or rare the material, lack of basic imagination will always show once the novelty has worn off.

Harvey Littleton in his book (*Glass-blowing: A Search for Form*) explains that his creative method is to involve himself in the act of working hot glass and

simply be prepared (primed) to recognise form as it emerges. The flaw in the 'seeking by finding' method is that it is totally dependent on the artist's ability to evaluate and select forms as he is confronted with them. If his experience is mainly of working with the material, an incestuous spiral is created which sets up fewer and fewer opportunities for genuine creativity to occur.

It seems essential that anyone heavily involved in working a material as rich as glass should be prepared to spend some of his time developing and maintaining a formal vocabulary which is generated independently of the material. The methods by which this is achieved are varied and well known; drawing, natural form, architectural systems, modern technology are some of the areas which motivate contemporary designers. Emil Gallé was influenced by natural form, microphotography and glass history. Erwin Eisch operates as a free sculptor whenever his glass work loses momentum. Genuine creativity, as Arthur Koestler points out, is often triggered by a meeting of elements which do not normally meet; the simplest example being humour. Without a constant injection of new ideas and contributions glass, like most activities becomes self-generating and limited.

Glass itself was a discovery which was the result of the meeting of many other arts and technologies and a synthesis of them. At regular intervals throughout its history there have been events which have kept it mobile and changing, from military conquest (Greek, Roman and Victorian Empires), trade (Venice), emigration (French Huguenot migration to England), new glass types (Ravenscroft and lead crystal) and new market pressures (Industrial Revolution). Each one of these events created the disruption of existing glass industries and the stimulation of a new direction. These events were outside the control of the glass worker and not always welcome. It is therefore important to realise that twentieth-century crafts are now largely immune from the enrichment of such exterior forces. As the crafts are selfconsciously employed for more or less artistic purposes, it is necessary for its practitioners to bring about new ideas themselves by selfconscious means.

Two of the twentieth century's prime glass artists spent much of their lives away from the material. Marcel Marinot was a member of the Fauve group of painters until he started working with glass at the age of 29, and he continued painting and drawing for the rest of his life as a source for glass ideas. René Lalique switched to glass after half a lifetime as a top art-nouveau jeweller, and created glass objects which were very different from his jewellery, and which made a major contribution to twentieth-century glass in particular and the Art Deco style in general.

In recent years glass has suffered from its instant novelty appeal to artists looking for new materials to exploit, and its very isolation from other materials makes it attractive from this point of view, and helps to create a barrier from basic criticism. Glass objects are too often immune from judgment; critics seem to be reluctant to employ criteria used for the assessment of other media. In my opinion an object made from glass must be capable of existence alongside the same kinds of object made from other materials. It cannot hide behind a difficult or mysterious process or its unique material. Objects which are designated as glass sculpture must be judged alongside general sculpture and not cling to a special sub-category. It also seems important that the difference between a sculpture and a sculptural object must be recognised. A glass object may be sculptural, meaning that it borrows the formal freedoms of sculpture but does not presume the cultural pretensions of fine art. Such an object could be a rich decorative or stylistic object.

The ensuing chapters on glass techniques are therefore to be understood as an

attempt to bring glass into the category of another material for the craftsman/artist to use. It *is* a special and even unique material, but these qualities do not mean that it functions best in isolation. Kiln manipulation does not require a hard won physical skill or even special plant or equipment. All of the techniques described can be carried out within existing ceramic facilities, and the raw materials are easily available.

The raw materials

The glass blower starts with the basic glass batch which is fused in his furnace for him to work in a molten state. The kiln worker is one stage removed from this and relies on buying his glass in frozen form from various sources, in doing so he acts in the same way as his pre-Christian counterpart, and not for the last time.

Sheet glass

This is the largest and most easily obtained type of glass. At its simplest it comprises soda lime window glass in plain sheet form. It is mostly made by the float process, i.e. cast onto a bed of molten tin. It is mechanically accurate and has a fire-polished surface. It is readily available in weights from 2 mm to 12 mm ($\frac{1}{8}$ in to $\frac{1}{2}$ in) in sheets, with heavier weights up to 20 mm ($\frac{3}{4}$ in) on request.

It is a hard glass with a very definite green cast to it; it is good for most kiln work, having very little stress. It is easily cut, bends and fuses well, accepts enamels and metallic lustres, and because of its accurate surface is excellent for trapping air bubbles by sand-blasting. It does, however, suffer from de-vitrification and does not take to re-firing well. In its thinner forms it is a relatively cheap raw material with a great range of possible effects. It is also available in more varied forms.

Patterned sheet

This is created by pouring hot glass over a roller to impress a pattern onto the surface, and is available in a number of surface patterns and a limited number of colours, all of which are compatible. It is brittler than plain sheet to cut, but useful for adding texture and colour to mid-temperature fusing and bending.

Architectural tints and body-coloured sheet

This is sheet glass produced by the float process, and is produced in two forms, either body-coloured in a range of bronzes and greys or as plain window glass with a number of thin coatings of reflecting metallic surfaces. These are relatively expensive but can be very effective. Neither the body colours or the tints change much in firing. The metallic coated versions are particularly useful as the coating can be selectively removed by light sand-blasting to create a two-colour pattern within the sheet which persists when fired.

Antique sheet

This sheet glass is hand made by the cylinder method, basically for stained glass use, but is very suitable for kiln use by virtue of the extensive colour range, varied internal effects, bubbles, streaks, swirls and irregular hand-made surfaces. Sheets are available in solid colour (pot metal) versions or with thin layers of colour on the surface (flashed). They are expensive, only available in small

sheets approximately 45 cm (18 in) square and are very rarely compatible and therefore cannot be mixed.

Slab glass

Solid slabs, usually 20 mm × 170 mm ($\frac{3}{4}$ in × 6 in) square, are made for architectural concrete and glass applications. They come in a variety of rich colours. They are expensive, but useful for heavy open kiln casting where lumps do not give the right weight and transparency.

Glass rods

Produced in a variety of weights (usually between 5 mm and 15 mm ($\frac{1}{4}$ in and $\frac{1}{2}$ in) diameters), glass types and colours, these are manufactured predominantly for lamp-working and millefiore applications. With care they can provide

61 Rods: a variety of sizes from 1 to 15 mm ($\frac{1}{16}$ to $\frac{5}{8}$ in).

Rods packed into a mould
which has been lined with
ceramic fibre and bound with
copper foil for strength.

63 Detail of a cast, using rod
sections packed together (see also
figure 18).

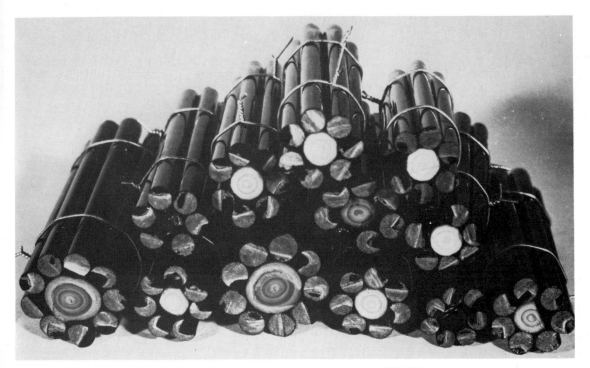

ranges of compatible colours for combination work. The manufacturers can usually provide a list of which of their colours can be mixed, or it is possible to conduct simple tests to establish compatibility (see the section on kiln problems). They are relatively expensive but provide a wide variety of permutations for kiln work.

They can be lamp-worked to provide curves, fine threads, twists, combination rods as kiln firing components. They can be bundled and pulled in the glasshouse or cast in the kiln to provide multicoloured and patterned cores for cutting and sawing into segments. They can be used as rods, or cut into small lengths, or even crushed to provide powder and grain. It is no accident that the ancient glass workers exploited the rod more than any other raw glass form.

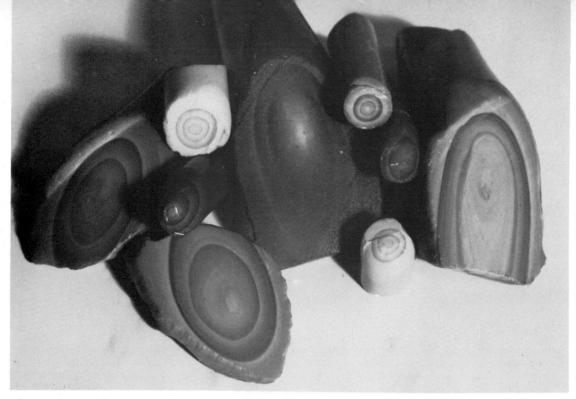

Lump, powder and grain glass

Glass can be bought as irregular or regular solids for breaking down into small particles or for use in kiln firings in lump form. They can also be used to pull rods from, providing that there are glasshouse facilities available. It is possible to obtain or make glass in particle sizes which vary from lumps of $\frac{1}{2}$ kilo (1 lb) to dust of 200 mesh like fine flour with all the variations of powder and grain size inbetween. It can be used in many ways and has a range of qualities which are its own.

Once you break down glass into a number of separate pieces it is difficult to restore it to transparency by reheating into one piece. In fact once the pieces get

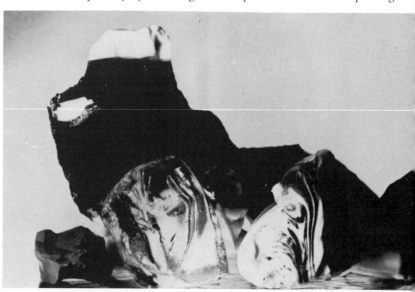

68 Contemporary glass ingots, available in a wide range of compatible colours.

69 Grain, chip, granule, bead, ballotini and capillary glass.

below a certain size it is impossible. Anything made from powder and grain will have a translucent but granular structure and is very different visually from poured or solid kiln-cast glass. It is possible to fuse grains together in a number of stages, so that at the lower end of the temperature scale the individual grains simply stick to one another without spreading, and the resulting form is open and porous (figure 70).

At high temperatures the grains will soften, flow and by settling exclude the air spaces between them. A form made by this method is solid and it is not possible to see the individual grains. The texture and internal structure characteristic of crushed glass work is complimented by the use of clour. In no other way is it possible to create spreads, mottled and patterned areas within the same piece except by mixing finely ground glass together in a mould.

Glasshouse facilities

Where hot glass facilities exist along side kiln techniques it is possible to make some of these instead of buying them. This also gives rise to certain possibilities. By making rod, spun discs or rolled sheets from the same glass they would all be compatible for kiln fusing. Components, kiln fabricated, could be re-introduced to the glasshouse for combination with blown work, or blown sections could be made for use in the kilns with furnace-made objects. This two-way traffic between kiln and furnace is an area of great possibilities. The different time-scale of their production has usually precluded the production of such hybrids but they have much to offer each other.

Enamels

An enamel for glass is a colouring agent or agents suspended in a very soft glass with a specific fluxing point. It is this point which determines its firing temperature, so that an enamel which fires at 540°C (1004°F) is simply suspended in a flux which will flow and gloss at this temperature. Basically glass enamels are designed to do their job at a lower temperature than the parent glass which they decorate. The two main temperature types for kiln glass are (1) those which fire at 540°C (1004°F) which is below the deformation point of most glasses – these are meant to decorate inert forms which are not going to move in the kiln – and (2) those which fire at 710°C (1310°F) which are called bending enamels. These are to decorate pieces of glass, usually sheet, which are going to shape at the same time as fire enamel onto their surface. If enamel is underfired it will be matt in appearance because its base glass will not have reached its flow point. If it is overfired much of the colour will have boiled away and the result will be a weak, pitted surface.

Enamel is best bought in powder form, for this gives it a greater degree of flexibility. It can be used dry to dust, sieve or stencil onto glass. It can be ground in a pestle and mortar or in a ball mill to make it finer and used with a variety of mediums to paint onto glass; or it can be mixed with screen medium and either screened direct onto glass or onto transfer paper and from there to the glass prior to firing.

In addition to standard opaque and translucent enamel colours there are a variety of specialist versions: crinkle enamel, which imparts a grainy dappled texture, etch enamel, which gives a soft acid etched colour to the glass, and metallic glass lustres, which are precious metals suspended in a medium for painting onto glass and firing into the surface – the main ones are silver and gold, but a wide range of soft metallic colours are available.

70 Detail of a fused bowl by Clifford Gomersall. This is a mix of crushed glasses and trails made from hot glass. The difference in texture is a feature of the finished piece.

The kiln

Heat is the trigger which is used to cause glass to move, and a kiln is the means by which heat is introduced to the glass. At its simplest, a kiln is a controlled environment which can be heated, with the means of judging the heat and monitoring it. It must also have the means by which the heat can be gradually reduced back to room temperature.

It is possible to design and produce a specialist kiln for each specific forming operation and there are some exotic versions in existence. However, this is only economically possible when the same object-type is produced in large numbers. Specialist kilns are expensive and hamper experiments by restricting the uses to which the kiln can be put. Flexibility is the main quality to look for in choosing a kiln.

A good glass forming kiln, therefore, is a simple refractory box with a heating system, a method of controlling that system, a door through which to place the glass components within it, and a means of visually monitoring the process of forming by direct contact at the crucial temperature. Above all, kiln working is a visual process and any modifications to a kiln to produce a special effect must safeguard this.

Having obtained a basic kiln which is an uninterrupted box it is then possible by the use of refractory bricks, batts and kiln furniture to convert it to a variety of different uses. Thereby flexibility can be achieved and the ability to experiment maintained. Heat is usually provided by gas burners or electric elements.

The main difference between gas and electricity as a fuel is that gas requires a steady flow of air to maintain it and this means that a gas kiln is constantly drawing air into it from underneath and expelling hot air and gases out through its stack. This fact makes a gas kiln a better environment in which to fire enamels, lustres or to carry out any process which requires the burning off of unwanted compounds like mediums, organic glues, wax residues or water from mould materials. These are all carried out of the kiln via the flue and it is advisable to increase the kiln's ventilation to encourage this to happen between 250° and 350°C (482° and 662°F). Otherwise, providing it is possible to control them equally via their instrumentation, there is little to choose between them as fuels.

Heat must be introduced to the glass evenly and indirectly. This means that each part of the glass must be at the same temperature and it must not be in receipt of any direct radiant heat from burner or element. The way to achieve these conditions is to have burners and elements evenly disposed within the kiln to begin with, the ideal being elements on all internal faces including the door, in the case of electricity, or to have the luxury of a circulating fan in the case of gas.

Electric kilns

Heating elements provide local and radiant heat, both of which are undesirable

69

Electric kiln

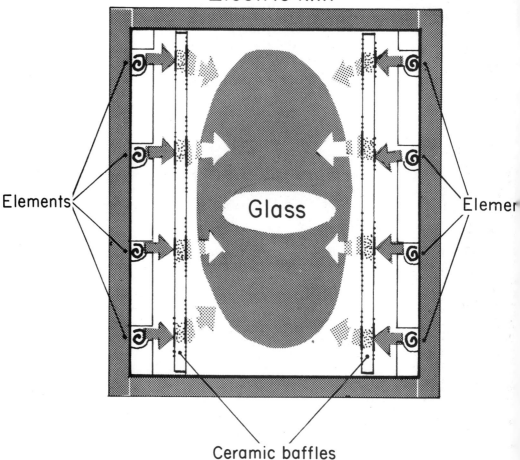

Elements

Elemer

Glass

Ceramic baffles

71 Using ceramic baffles is the basic method of creating an even temperature enclave within the electric kiln.

conditions. The disposition of the elements can help to spread the heat. The ideal of elements disposed on all internal faces including the door can be modified. The roof is the best face to leave unheated as heat rises and it is hard to baffle elements set in the roof. It is also sometimes convenient to leave the door clear so that it is not necessary to baffle these and interfere with vision. If this is done then the face opposite the door is best left clear to balance this.

Bearing in mind these requirements, a good kiln environment is the one shown in figure 71, with heat coming from two sides only. This leaves the floor free to support moulds or frames. The glass is best protected from radiant heat by ceramic kiln slabs cut to size and lining the kiln in front of the elements.

These perform a dual role; they protect the glass from direct heat, and by acting as convectors once they have absorbed the heat, they ensure evenness of heat within the kiln and retain that heat to help with annealing. A kiln with built-in baffle walls might seem to be the answer, but this would in itself make some processes difficult and cut down on flexibility. I prefer to adapt the kiln for specific jobs. This presumes that a flexible kiln is what is required and that its function is to produce individual items or limited series. If extended repeatability is required, it is possible to design a specific kiln for series production of one object.

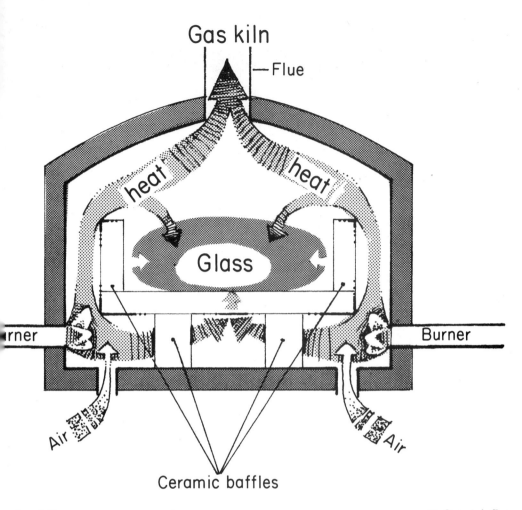

Gas kiln

Flue

heat

heat

Glass

rner

Burner

Air

Air

Ceramic baffles

Gas kilns

Heat is introduced to gas kilns through burners. As flames, they burn air, and require a constant flow of air through the kiln. It is more difficult to control the heat of a burner at the low and critical temperatures. It is important for two reasons to protect the glass from direct heat and flame, to prevent sudden thermal shock to the glass when the burner is lit and to spread the heat produced gradually through an intermediary material (figure 72; see also figure 160).

Controls

Variable heat input is desirable, that is the ability to heat all the elements gradually rather than achieve it by having a few elements full on and some completely off. This makes gradual heating and cooling possible. In addition an accurate method of reading the internal heat of the kiln as near to the surface of the glass as possible is necessary. This is usually obtained by the use of pyrometer and thermocouple. The ability to accurately read kiln temperature is necessary not at the forming temperature when the operation is visually controlled but to enable annealing to be achieved, that is the release of strain during the cooling of the glass to room temperature.

72 Ceramic baffles are also used in the gas kiln (see also figure 160).

Temperature

Usually glass is placed in a kiln cold, heated to the point at which it performs as required, frozen briefly and gently returned to room temperature. Except with specific processes like enamelling, where an exact temperature is required every time, it is important to realise that it is the point in time at which the glass deforms which is important and not the exact temperature at which this occurs. The temperature will vary slightly with many factors, like weight and material of the mould, type of glass, weight of glass etc. That is why it is important to be able to see the glass well while it forms and be able to stop a process at a precise moment, usually by lowering the temperature a few degrees to freeze the glass into a given position.

Each type of glass has a point at which it changes from a liquid to a solid in scientific terms. Below this exact temperature it can be cracked by excessive or uneven thermal shock, above it, it can be heated as quickly as desired, unevenly or directly heated. The higher its temperature rises above this point, the less its viscosity, so that it moves through the rubber, elastic and treacle stages already mentioned.

Some generalisations are possible at this stage. Once the annealing point (transformation from solid to liquid) has been passed on the way up, the faster the fabrication point is reached the better. Once the fabrication point has been achieved the sooner the annealing range is reached again the better. This is to avoid the deterioration of glass which occurs when it is held at a high temperature for too long; this deterioration can take form of shrinkage or devitrification where the surface of the glass loses its gloss and becomes milky or crystalline.

Do not take the glass to a higher temperature than necessary to form it, particularly in bending operations. This helps to maintain the glass in as good a condition as possible. In the commercial production of car windscreens, hinged moulds are used with counterbalancing weights to force the glass to bend at a lower temperature than gravity alone would cause. This means that there is less chance of marking the surface of glass in an object where the maintenance of perfect visual accuracy is essential.

Heat levels and viscosity

The reason for heating glass is to reach a given point in its viscosity transformation from solid to liquid. It is therefore a convenient point to list four hypothetical stages along that transformation. The approximate heat levels are for soda-lime (window) glass; softer glasses, like lead, will perform at lower temperatures and harder glasses, like borosilicate, at higher temperatures. They are approximate and will vary with actual objects.

1 *Inert level*

This is the stage from room temperature to annealing point, in the case of soda-lime window glass this would be 540°C (1004°F). This is the first point at which any heat process can be carried out. Whilst the main body of the glass is still solid, and will not bend or deform, its top surface is just soft enough to accept low firing enamels and metallic lustres. Most of these are designed to flux at this temperature, but this can be exceeded by 20°C (68°F) without spoiling either the glass or the enamel, and this procedure is often used as a precaution against underfiring due to an optimistic pyrometer.

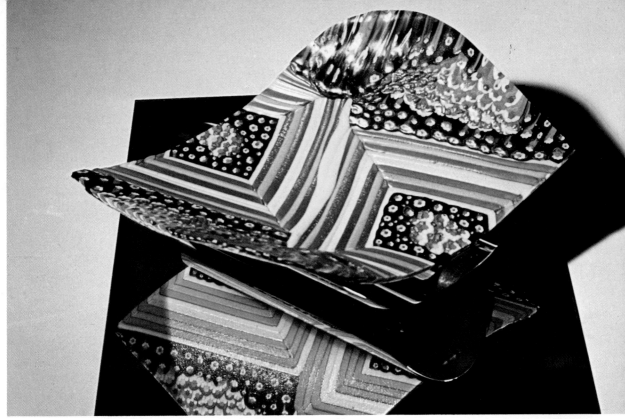

1 A piece by Frank Jurrjens made from fused canes, polished and mounted on a metal base

2 Sawn sections, by Rob Fisher – sheets of plate glass fused together, with powdered enamels trapped between each sheet

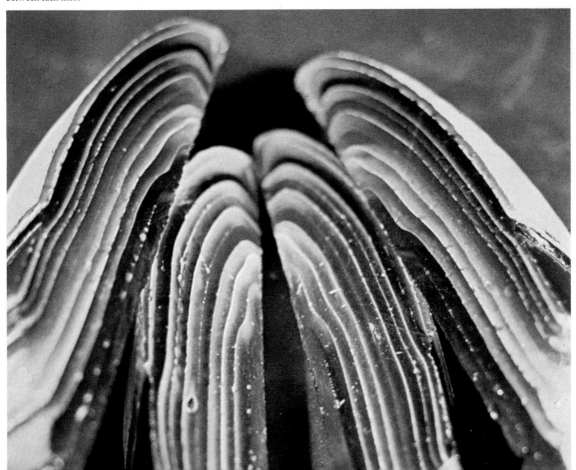

3 A rare alabastron (Hellenistic period), fabricated by fusing rod sections together in a mould to create a blank for lathe turning

4 Sawn section from a block made by mixing coloured glass in a crucible and pouring

2 Bending level

This is the stage from annealing point to the softening point at which glass will start to stretch. In the case of window glass it extends from 540° to 710°C (1004° to 1310°F) but its optimum is closer to 650°C (1202°F). Within this range it is possible to bend glass sheet or rod into or over moulds without the surface distorting very much or the thickness or section changing. It is therefore not possible to impart much deliberate texture at this stage. It is during this range that bent glass for building is carried out and car windscreens formed. Fusing of separate pieces can only be carried out at the top of this temperature stage and then only to level three in figure 87.

3 Stretching level

This stage extends from the scientifically named softening point; with soda-lime glass this is 710°C (1310°F) to an undetermined point around 820°C (1508°F) when it can be said to have entered the fourth stage. Over this hundred degrees or so, stretching and softening will occur at increasing rates. These actions will involve the movement of material from one part of the form to the other by flowing, therefore creating thicks and thins in section. It is this stage that is reached in part supported pieces, where a mould or former is responsible only for part of the form and the unsupported glass deforms under gravity.

Stretching can be deliberately used in the creation of form. Visual monitoring is crucial during these stages, the difference of a few degrees or minutes can make the difference between success and failure.

Fusing up to stage four on the diagram is carried out at the mid point of this range and the picking up of texture or shallow relief casting, where the glass is supported on the mould but becomes soft enough to flow into fine depressions.

4 Flow level

Extending from 820°C to 1000°C (1508° to 1832°F), this is the stage during which glass reaches its point of least viscosity and it can be poured like thick treacle. It is at this level that crucible pouring can be carried out, effecting forms through the use of reservoirs in kilns and the re-fusing of powder, grain and rod into homogeneous mixtures.

These levels are not exclusive, and except for the annealing point and enamel firings do not have precise boundaries. Some objects may be fired more than once and use more than one stage. Fusing an object from a number of smaller pieces and then bending it for instance. Many extensions and variations are possible involving, in some cases, cold processes like sand blasting to change the surface prior to firing and therefore affect its behaviour. In other cases parts of a piece of glass can be protected from some of the heat to achieve two stages within the same object.

In the following chapters, the glass forming techniques are introduced within the format of the four stages of viscosity, with all of the processes involving each temperature range together.

Inert level techniques

Heat decorated glass

This involves the affecting of the surface of glass by fusing onto its surface a variety of glass-based agents to colour and texture its surface by addition. It involves the first viscosity level where the main body of the glass remains inert. Texture and pattern which is integral to the surface involves level three, and will be discussed then. Moulds are not required for these processes. Kiln shelves are suitable with a minimum of separator on them.

Enamels

73 *Below left and right* Enamel, hand painted plaques with applications of crushed glass, crinkle, capillary rod and glass beads.

The more conventional of these heat-added surfaces are enamels which are available in a wide variety of colours, opacities and textures. The way in which enamels are applied to glass presents a great range of textural possibilities (figures 73a and b). Mixed with American Turps and fat oil, and applied by brush, they can be used to create subtle halftones, opaque areas, delicate line work or sgraffito patterns; it is an activity requiring immense skill. Enamel can be sieved direct onto glass to create a granular body colour or applied through stencils to achieve patterns. The use of sponges or other materials rather than brushes opens up a wide range of textures.

Where enamels are applied as powder (in sieving), a light coat of fat oil can be applied to the glass to aid adhesion and make the surface slightly less vulnerable to disturbance prior to firing. This in itself can be used to create a pattern by brushing a solution of gum arabic into the required configuration on the glass and dusting enamel onto it. When the gum sets, the free enamel can be removed by shaking and the brushed marks revealed in enamel.

74 Decoration of enamel, fluxes, ballotini and beads.

Inclusions

There are inclusions which can be used to vary enamel surfaces (figure 74). The most versatile of these is crushed glass in many powder and grain sizes. These can be purchased or made by fritting, i.e. pouring molten glass from a ladle or crucible into water. This extreme thermal shock causes internal fractures and creates a fine grain glass form like sugar. This can be broken finer using gentle pressure. When fritting it is important to pour the molten glass into a great deal of water to minimise the creation of steam and its possible dangers. A small crucible full should be poured into a bucket full of water.

If you create grain by crushing cold glass manually, the production of very fine dust is a hazard. It is given off by any process involving crushing and the dangerous form is hard to see. The use of masks and containing clothing is essential; if possible keep the glass moist and perform the operation out of doors.

In crushed (rather than fritted) form this fine powder is mixed with the grains and if fired with it will cause clouding and scumming of the surface. To remove it, place the crushed glass in a container too large for it, add water until the water covers the glass by about 5 cm (2 in). By shaking gently, the fines will rise to cloud this water and can be poured off with the excess water; this can be repeated until the water is clear. The residue will consist of clear, even grains like those produced from the fritting process.

Crushed glass

Crushed glass can be used as an addition to an enamel surface, by mixing it with the enamel prior to application, or it can be applied selectively to already enamelled surfaces. It can also be used as decoration in its own right where it can create a textured surface, which can be heightened by light enamel applications. On the scale of these surface fusings, compatibility is not much of a problem. It is possible to vary the mix of glass types on the surface, for where cracking occurs it is unlikely to spread to the main body of the sheet, but will remain local and can be used as an extra texture as crazings in ceramic glazes are used. This is providing the grain size does not get too large and is not fused too deeply into the parent glass. If it is fired too high it will sink under the surface and take strain with it to the vulnerable centre areas. With all enamels and crushed glass amalgams they are fired sufficiently when they begin to gloss slightly. Enamels will of course have a fixed firing temperature, but a mix will not, and therefore a visual fix is necessary.

Glass objects

In addition to crushed glass and enamel any obtainable small glass objects can be diverted from their official use and find their way into surface decoration. A very successful type I have found are the ballotini range of glass balls used in

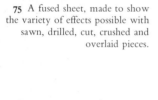

75 A fused sheet, made to show the variety of effects possible with sawn, drilled, cut, crushed and overlaid pieces.

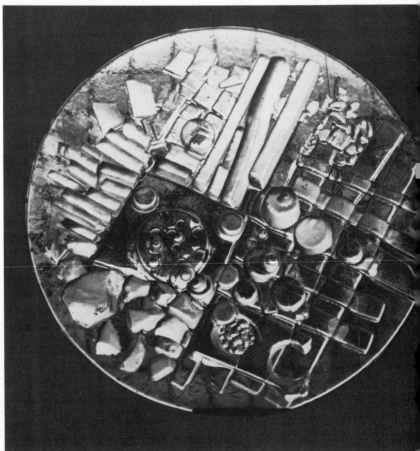

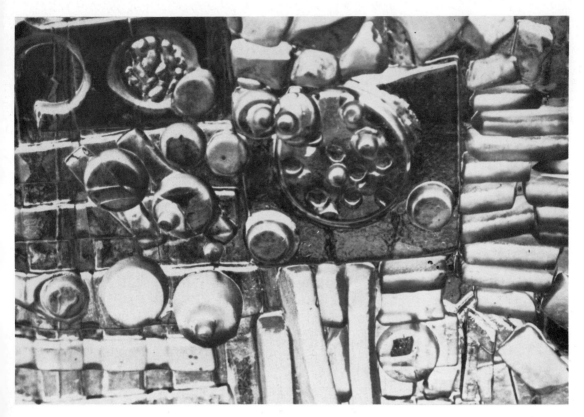

scientific apparatus. These are very useful as they can be bought in soda or lead glass in a wide variety of sizes from 1 mm to 10 mm ($\frac{1}{16}$ to $\frac{1}{3}$in). They can be obtained from any scientific suppliers by the kilo (or pound) and they offer a wide range of possible textural effects, by themselves or in conjunction with enamels (see figure 69).

Another source are glass embroidery and knitting beads, which can be bought from hobby shops and haberdashers, and are available in a wide range of opaque and transparent colours and sizes.

Even sheet glass itself can offer a rich source of texture and surface variation. Cutting, drilling, sawing, crushing all provide characteristic qualities, and pieces made by these methods can be fused to the surface of sheet glass (figures 75 and 76). The variety which can be squeezed from one sheet of window glass is a good first exercise in kiln-working glass.

Screen printing

In addition to direct application onto the glass, enamels can be screen printed using screening medium onto transfer paper and from this to the glass (figure 77). This gives flexibility of image and handling. It is possible to screen basic colours, dots, stripes or textures for cutting into shapes or photographically prepared images. Cover coat is required in addition to transfer paper and screen medium; this is applied as a final coat at the transfer stage, and its function is to hold the enamel in place and prevent lifting during firing. Many commercial decals are available for glass decoration; they are very cheap and with a little imagination can be used creatively.

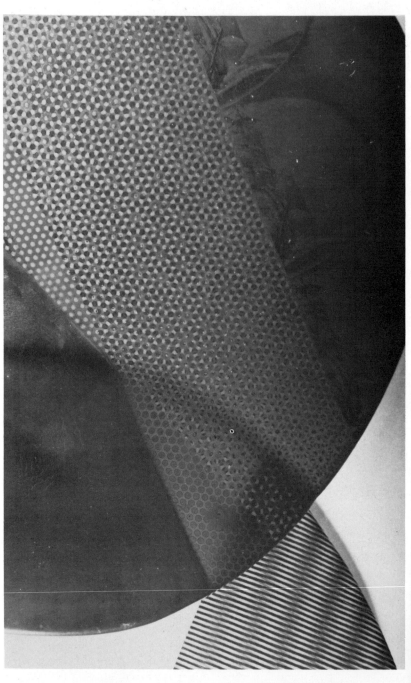

77 Detail of a sagged bowl by Frank Jurrjens, decorated by overlays of screen printed transfer enamels and sections of commercial decals.

The various compounds, metallic chlorides, bromides etc., which are used in the glasshouse to spray onto blown objects to give iridescent surfaces, can with care be used on objects in the kiln. They can be sprayed on by opening the door at a temperature in excess of 700°C (1292°F) or can be used in granule form by adding prior to firing when the glass is cold. Some of the fumes given off by these compounds are dangerous and should not therefore be used unless adequate precautions are taken to extract or neutralise the fumes.

78 Detail of a sagged bowl by
Frank Jurrjens, decorated by
screen printed transfers and hand
printed metallic lustres.

Metallic lustres are too expensive to screen and are restricted to application by
hand (figure 78). They are easy to apply wrongly; the most common mistake is
to create a layer which is too heavy. The result of this is that some medium will
be trapped and will prevent the adhesion of metal to glass. It is almost impossible
to apply lustres too thinly, I often use two brushes, one to apply and one to
spread the lustre. With the exception of gold and silver, lustres do not fire on as a
solid, opaque surface; they are subtle surface sheens.

Bending level techniques

This stage is concerned with shaping pieces of glass, that is, bending; other alterations like texturing or flowing of material are done at higher temperatures. It is not possible to cover all of the permutations, so I have chosen to work at two levels at this point, to take a simple form through its manufacturing methods to elucidate their main differences and then to illustrate and discuss some more complex case histories to give an indication of the use of these processes and techniques in the production of a piece of designed work.

Like all kiln processes, the bending of a sheet of window glass involves placing the glass in a kiln, heating it to a specific viscosity, which alters its shape, freezing it and thereby trapping it in the form which it has adopted. This form can be wholly determined by a mould, where the glass softens until it is completely supported by it, or only partly determined, where the glass is only partly supported and areas of it can be allowed to react freely to the heat. The major ingredient in forming sheet glass is gravity acting upon the softened material. A result of this is that controlled return curves are not possible, the steepest gradient can only approach the vertical.

There are three main methods of bending, or sagging or slumping to give it all its names (although at this stage bending is probably more descriptive). These are to bend glass through, over, or into moulds of various kinds. For our purpose we will presume that the desired shape is a simple hemispherical dome.

Method 1 Sagging through a mould

This method involves supporting a sheet of glass over a circular hole so that, as it softens, it stretches through the ring, with the edges of the sheet still supported by the mould. It has to be well supported along its rim to a depth which forms a resistance to the downward pull of the bending glass. This can obviously vary with a variety of factors, like weight of glass, size of hole etc., but a 150 mm (6 in) disc of 6 mm ($\frac{1}{4}$ in) glass would require a 40 mm ($1\frac{1}{2}$ in) collar minimum. This means that the resultant dome is fire-polished and unmarked, but that it has a flat collar which will be marked by contact with the ring mould. This would have to be cut off and the edge polished if it cannot be accepted or designed into the form.

The best material for a mould of this kind is sheet steel of at least 3 mm ($\frac{1}{8}$ in) thickness to avoid heat distortion. This steel collar should be cut into four sections to facilitate easy removal from the glass and to allow a slight movement potential while forming. These mould sections can be supported on kiln props to the desired height.

The steel area in contact with the glass will need a barrier layer to prevent the glass from sticking to it. A number of separators can be employed, giving a variety of possible surfaces. Dry plaster can be sieved onto the mould once it is in position within the kiln, this can be left granular, as it falls, or compressed to a

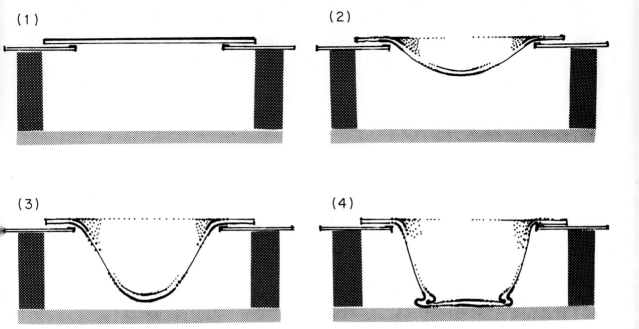

(1)

(2)

(3)

(4)

smoother or textured finish. French chalk (or talc) can be used dry in the same way or mixed with water and sprayed for a smoother finish. Some white emulsion paints of the non-vinyl variety can be used for these low temperature bendings either painted or sprayed. For repeatability, or if the extra cost can be justified, an excellent separator is a layer of 1 mm ($\frac{1}{16}$ in) compressed ceramic fibre paper (figure 101) cut out to cover the contact area of the mould. If left undisturbed it can be used many times and imparts a soft, even texture to the rim area.

The four stages in deforming a sheet of glass by sagging through an aperture mould are shown in figure 79. In the first stage, the sheet of glass is placed onto the mould in the kiln and set up horizontally with a spirit level. It is important to heat up this mix of materials slowly to avoid hot and cold spots in the glass which could cause cracking. The areas in contact with the metal mould are particularly liable to lose heat to the metal in the first 200°C (392°F) and it can help by putting small glass spacers at the extreme edges of the glass. The glass should stay inert until at least 600°C (1112°F) when observation of its progress should begin.

Once this stage has been reached it is important that temperature rise should become gradual as the whole process speeds up alarmingly once the ratio weight to glass softness allows movement. It may even be necessary to hold the temperature constant for a while, and if no further appreciable movement occurs to raise the temperature gradually. At this stage observation every ten minutes is adequate.

The third stage is the time, around 700°C (1292°F), depending on the glass, when observation should be almost constant. The difference between obtaining exactly the dome required and collapse can be only a few minutes of kiln time. Once the optimum point has been reached it is advisable to lower the temperature 50°C (122°F) to freeze the form and prevent any unwelcome further movement. In fact the faster the temperature is reduced to annealing point the better.

The fourth stage is the point at which the form is no longer determined by gravity but collapses onto the batt below, or, if the distance is too great, tears

79 The four stages in deforming a sheet of glass by sagging through an aperture mould: (1) the sheet is placed level over the aperture; (2) after 600°C (112°F) the glass begins to bend; (3) observation of the bending process should be constant at 700°C (1292°F); (4) the temperature must be reduced when the form collapses onto the batt.

80 Section stretching: the main cause of faults in gravity sagging is raising the temperature to the point where the glass does not deform as a sheet, maintaining a more or less even section, but to a point where the weight of the bottom section of the sag becomes too much for the over-softened middle section. The result is that the middle section stretches and perhaps tears. When this happens it is very rapid, and can be avoided by only raising the temperature slowly once the first stage of movement has been reached. In this way the glass is persuaded to deform without stretching too much.

81 A sample combination kiln forming, indicating the complex possibilities of combining methods. In this case, a gravity sag is set up over an interrupted one so that the aperture sag deforms and picks up the lower one, which has also deformed. The result in this example is like a footed bowl, and in the ancient world footed bowls were made by this method, particularly from fused cane discs. However the method can be used to create asymmetrical and sculpturally free forms.

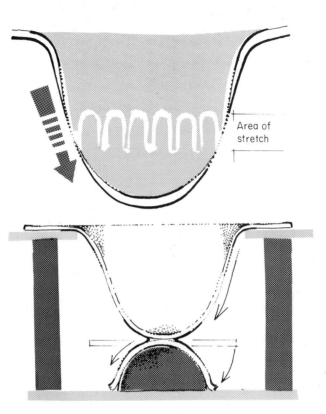

Area of stretch

and parts under its own weight. These characteristics can of course be used to advantage in the production of some forms.

A gravity melt of this kind requires careful monitoring and control during its critical forming stage. This is because the final curve of the dome is the result of weight versus viscosity and not mould contact. Once the unsupported area of the glass softens, the ratio of rate of bend to raises in temperature changes dramatically. It is also important not to take the glass to a temperature higher than that necessary to just do the job required. If this happens there is a danger of the glass stretching rather than just shaping (figure 80). The glass will then become thin at its steepest points and the dome uneven and flimsy. Once deformation of the sheet has begun the temperature rate rise should be slowed right down or even stopped. In this way it will be possible to achieve an even dome with the minimum of section loss.

As gravity is being used as the major forming component, it is a good idea to establish the horizontal and vertical axes of the glass and mould with a spirit level prior to forming. Extensions to this technique are as follows:

1 The sagging glass can be interrupted as it deforms by placing something in the way. This can be as simple as allowing the dome to flatten against a positioned kiln batt or as complex as making one sagged dome pick up another (figure 81).

2 The shape of the aperture can be changed, and the glass sagged through more than one (figure 82).

3 The basic sheet to be sagged can be changed. A fused lamination or combination of techniques will produce a form for sagging which reacts in a very different way from flat sheet glass (figure 83).

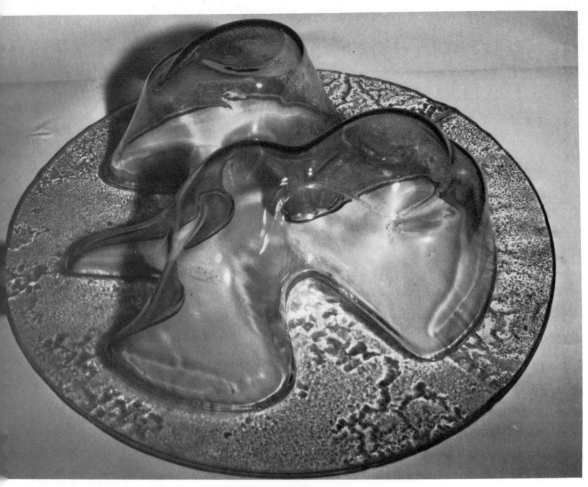

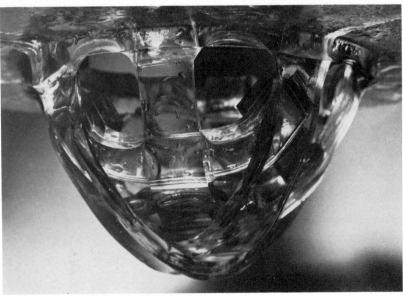

82 An aperture sagged form by Geoffrey Lamputt. This piece was sagged through two moulds placed above one another to achieve the complexity of form. This mould required a number of expansion gaps.

83 Detail of an aperture sag by Geoffrey Lamputt. Instead of a single sheet, strips of glass have been used to create a complex set of forces.

(1)

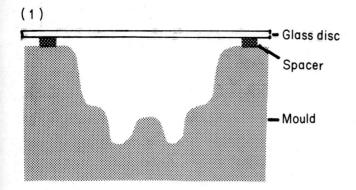

(2)

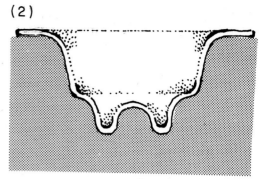

— Glass disc

Spacer

— Mould

84 By sagging softened sheet glass into a mould, the outside profile of the glass can be exactly determined by the mould. Obviously asymmetrical forms of great complexity can be achieved by this method. Small glass spacers can be used to avoid glass/mould contact until after all the materials are at an equal temperature. At the temperature required for the glass to take the form of the mould (higher than for gravity forming) such spacers would be well integrated into the main sheet and be hardly detectable. Forms produced this way are of course marked by mould contact and allowance must be made for this in the design of the form.

Method 2 Sagging into a mould

Here the entire shape is determined by the mould, heat and gravity are used simply to make the glass collapse into it (figures 84 and 85). The advantages of this method are that one is not restricted to symmetrical or gravity-induced forms, and it is possible therefore to predetermine the desired form accurately. As the glass touches the mould across its entire surface, it will not be fire-polished and will have picked up the texture of the mould surface.

As with the other methods it is advisable to support the glass on small pieces placed at its extremities. These lift the sheet from the mould surface and prevent uneven heating during the early part of the firing. They will be absorbed during firing. They also encourage the glass to sag accurately from the middle outwards and allow any moisture from the mould to evaporate and therefore prevent blow-backs when the glass becomes soft.

There is a greater risk of overfiring than with the previous method as it is hard to see when the glass is touching the mould. A piece of paper crumpled and thrown into the hot kiln creates a good light to see by at this stage.

An extension of this method is that previously worked pieces of glass can be placed in the mould for the sagging glass to pick up.

Method 3 Sagging over a mould

This method eliminates the need for a support collar (and therefore excess glass) but can create a slightly uneven rim. Forms produced by this method are marked on their interior surface by mould contact (which may be textured or patterned) but have a fire-polished exterior. It is also possible to form the rim by incorporating a ridge in the mould to create a stop for the glass. It is difficult to sag by simply balancing glass on the mould (particularly if this is cast-iron) as it creates a cold spot at the contact point and encourages cracking. It is better to support the sheet delicately above the dome so that when it begins to deform it slips off the supports and forms over the mould.

The stages in deforming a sheet of glass by interruption rather than free gravity sagging, are shown in figure 86. In the first stage, the glass sheet is supported just clear of a dome mould at its extreme edges by kiln props. This is to prevent the heat absorbing qualities of the mould from causing a cold spot in the centre of the glass and creating fracture stresses during the important first 200°C (392°F). The glass will remain inert until it is in the vicinity of 600°C (1112°F).

In the second stage, once the glass softens enough to touch the mould the danger of heat imbalance is over. It is now important to remove the kiln props as soon as possible to allow uninterrupted sagging to continue. They can either be removed with tongs or simply pushed out of the way. When this is done it is

85 *Above opposite* A sheet of glass sagged into a plaster and sand mould: the fine cracks in the mould surface are not picked up by the glass.

86 *Below opposite* The stages in deforming a sheet of glass by interruption rather than free gravity sagging: (1) the sheet is supported at its extreme edges by kiln props; (2) the softened sheet touches the mould; (3) the props are removed; (4) the sheet continues to sag over the mould.

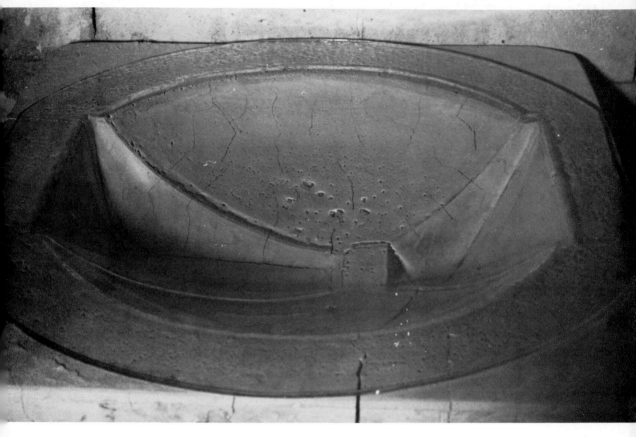

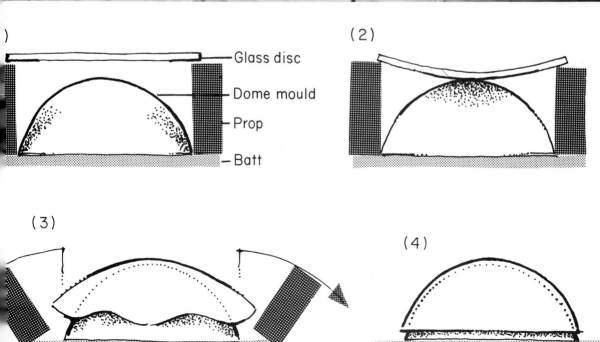

(1)

— Glass disc

— Dome mould

— Prop

— Batt

(2)

(3)

(4)

important not to touch the glass with the implement used. A well charred stick would minimise the chilling effect of accidental contact.

In the third stage, with the props removed, the glass can continue to sag. Its first tendency will be to adopt skirt folds, but if the temperature is raised slowly these should settle out.

In the fourth stage – the final form – it is unlikely that the rim of the dome will be exactly horizontal, but if the sheet was placed accurately over the mould, and if the temperature has not been too high, no undue creep of the material should occur. A form made by this method will be fire polished on its exterior and will have accepted the texture or pattern of the mould on its interior surface.

An extension of this method is to sag more than one sheet of glass at a time over a mould. This can be done by lightly sieving talc or french chalk between the sheets; this prevents the glass from sticking and allows the pieces to come apart after sagging.

Stretching level techniques

This stage involves some material flow accompanied by an increase in stickiness and a tendency to 'wet' surfaces with which the glass comes into contact.

Fusing

This involves the combination of a number of separate glass components into a single agglomeration by heating them to the point where they soften, and a flow of material occurs across each piece. There are a number of points to note. Glass taken to fusing temperature – usually in the range 750°–800°C (1382°–1472°F) – loses its rigidity so that it will take on the form of the surface on which it is fused. If this surface is not flat, gravity will act upon the softened glass and encourage it to move to the lowest available point. This has to be considered when designing a form. Fusing is well suited to producing flat objects, but if a three-dimensional form is wanted you must either fuse first and shape at a lower temperature, or design so that the flow is kept to a minimum, or itself becomes a feature.

The four stages in the integration of separate pieces of glass in fusing are shown in figure 87. In the first stage, the pieces are positioned in a kiln but are totally separate. In the second stage the two pieces soften and the outside skins of the glass, which are marginally stickier than the interiors bond together. This can occur as low as 650°C (1202°F); a unity created at this temperature is not really a fusion and is unstable. On cooling, cracking and possibly fracturing would follow. Many failures in fusing are caused by this type of low temperature, surface sticking. It is very similar to bad metal welding where superficial adhesion only is achieved, and for similar reasons.

87 The integration of separate pieces of glass in fusing: (1) the pieces are positioned; (2) the softened exteriors bond together; (3) at 700°C (1292°F) the pieces fuse into a continuous form; (4) when complete glass flow happens there is a loss of form.

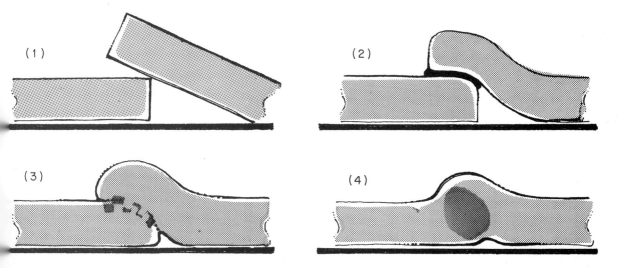

(1)

(2)

(3)

(4)

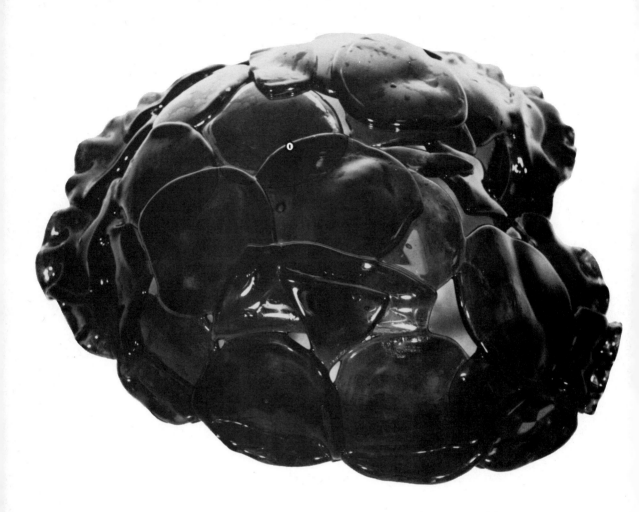

88 A fused form by Denise Lewis, made by placing discs over a mould. The result has a fire-polished exterior.

In the third stage, when the temperature is in the region of 700°C (1292°F), there has been some intermingling of the separate glass pieces and they can now be talked about as fused, that is, a continuous form. The forms, although soft, still register visually as separate. In the fourth stage, at the point at which complete glass flow happens, there is strong fusing but a loss of form. Either the third or fourth stages are acceptable fusings structurally.

The prime requirement of fusing is that the individual pieces are compatible, that is, they all have the co-efficient of expansion. This will be easy when using a commercial, quality controlled product like window glass, when it will be possible to fuse sheet, strips and crushed pieces together with impunity. If you have access to a glass furnace you can make sure that all of the elements to be used in a fusing are made within the same working session and from the same glass. It is simply impossible to fuse glasses of different co-efficients together, and if these must be heat joined, methods other than fusing must be used (see the section on glass solders).

The vocabulary of fusing is very rich. Fabricating a number of smaller pieces into a larger whole, so that the individual pieces do not entirely lose their integrity of form, gives a result whereby their shapes are still evident in the fused shape. This can create rich raised surface modulations which will catch reflected light and bend transmitted light (figures 88 to 91).

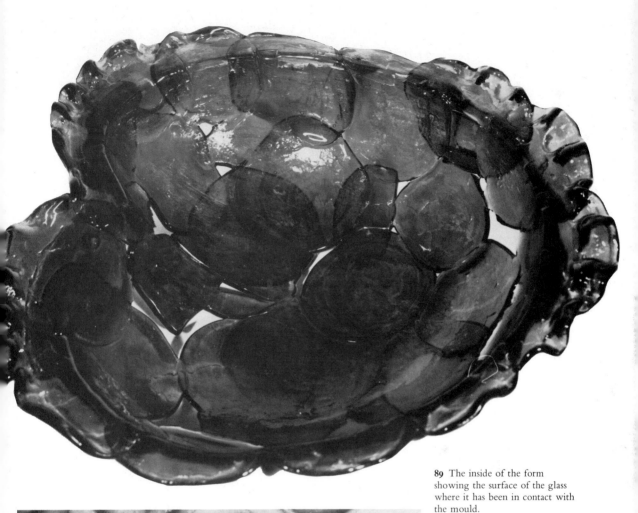

89 The inside of the form showing the surface of the glass where it has been in contact with the mould.

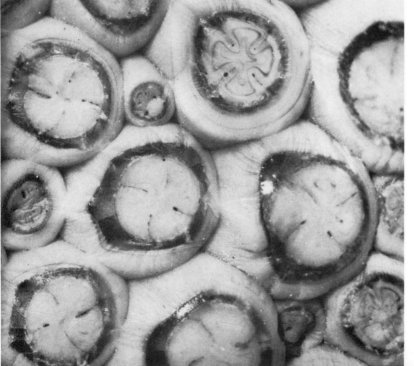

90 Detail showing cane sections fused together in an open mould. This shows the way in which they can be made to fuse without losing their individual shapes completely.

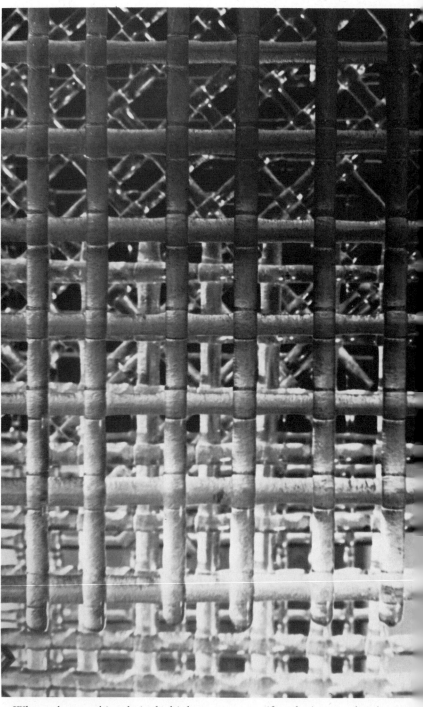

91 Detail of fused screens by Brendan Mooney, showing grids made from fused rods.

When taken to this relatively high temperature (for glass) some shrinkage occurs, so that two pieces of flat glass placed side by side touching one another would not be likely to fuse together but shrink away. To create a fused form it is necessary to build up layers to enable integration of pieces, either by overlapping or using a parent sheet to create an overall blanket on which to fuse.

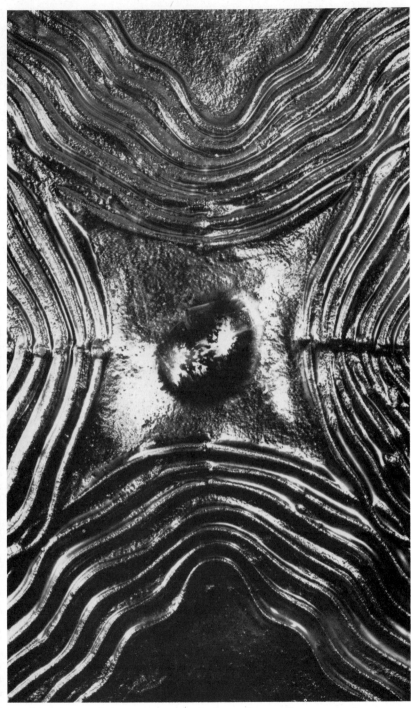

92 A sagged, mirrored sheet of glass, by Howard Cooper. The mould was a tray of sand with ceramic extrusions placed in it. The method allowed for a great deal of alteration between firings.

Glass taken to fusing temperature is also soft enough to accept the pattern, texture or shape of the support used to fuse on (figure 92). This gives an area for exploitation, providing that the glass can be released. While many materials can be used as moulds for fusing operations, most of them will stick to the glass. A number of other materials are used as separators to prevent sticking and achieve

glass release by acting as inert layers between the glass and the former bed. These separators (see the relevant section below) can be used for their textural quality. They are either dry inert powders or water suspensions of them which can be sprayed or sieved on. The powders can be sieved onto a dampened mould to give a soft, granular effect. If they are put on as a thicker layer, they can be compressed by tamping down with a strip of sheet glass or smooth wood to a fine uniform surface; this new surface can be used as a base for impressed textures using a variety of implements. If the glass is placed carefully on such a bed without disturbing the textures it will, on sagging, faithfully pick them up.

Before elaborating on textures and patterns it would be well to mention how to fuse with the minimum of texture where what is required is a fused sheet with a uniformly smooth, flat back where it has been supported. It must be accepted that any glass sheet which has a fine, mechanical surface (window glass) will lose this when taken to this range of temperatures. It is only possible to go some way towards retaining it.

The basic, flat surface on which to fuse is the kiln batt. The surface of this is vital, so select a good batt with an unpitted, unwarped surface, wash it and if necessary hone it with pumice stone or other abrasive to a smooth surface. You can now apply one of a number of different separators.

Warm the batt to about 100°C (212°F) and spray or paint a weak solution of french chalk and water onto its surface; the water will evaporate on contact with the warm ceramic and the result will be a fine deposit on the surface. It is worth experimenting to establish just how little powder needs to be used to achieve separation.

A smooth surface is also given by coating the batt with graphite paste (see the mould section), this is done by applying with a brush, burning off with a flame for a few seconds, and applying another coat. When this has been done three times the surface can be burnished to a shine. This surface will burn off during firing and has to be re-applied every time.

If a good finish is required in any kiln operation involving sheet glass, care must be taken in handling the glass whilst assembling it in the kiln. If you put dirty or dusty glass into a kiln you will get dirty glass out; even a finger print will fuse permanently into the surface if not wiped away. Prior to positioning, glass can be cleaned with distilled water or ammonia and then handled with a cloth or cotton gloves.

Texture and pattern

The simplest way of imparting a controlled pattern to glass fired to fusing temperature is to cast up a slab made from a plaster mix (see the mould section) onto a sheet of glass to obtain a fine surface. This slab can then be carved with a shallow pattern and used as a surface to cast glass on. This method is very sensitive to the quality of the marks put upon it, even the finest scratches are picked on the glass surface (figures 93 and 94). This method can be used in conjunction with dry powdered areas or the original plaster mix slab can be cast from a clay original. Casting from clay obviously gives scope for much greater depth of modelling than is possible with intaglio cutting of a cast surface. This brings a problem which occurs at all stages of kiln work where glass sheet is sagged into deep indentations. As the glass has truly softened rather than just bent, it can flow into undercut depressions; this must be avoided except when using certain mixes which can be washed from the glass (see the mould section).

The other point is that glass wants to shrink horizontally across its surface as it cools, and if it has sunk into separate indentations in the mould it will not have

93 A glass cast by Freia Schulze, made by fusing a pre-formed blank into a carved mould.

94 A fused sheet by Nicholas Yaxley, made from clear and coloured rods. The mould had a fabric texture on its surface which the glass has accurately picked up.

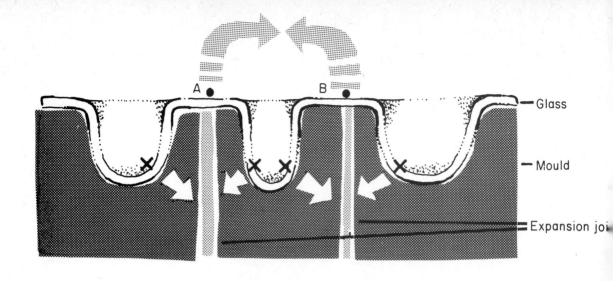

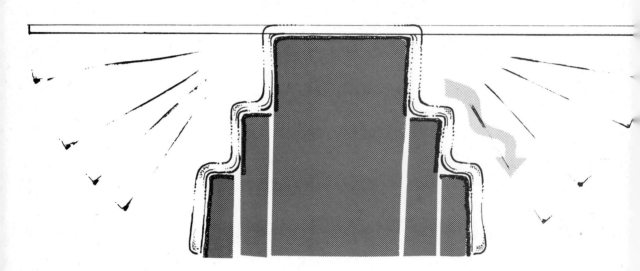

95 *Top* Where different parts of the same sheet of glass are sagged into separate depressions in a mould, expansion joints must be placed between them to allow the glass to contract.

96 *Above* A sagged form produced by deforming over a mould requires expansion joints, otherwise the pressure would cause breakage across the top of the glass, and even if fractures did not occur mould removal would be impossible with out sections.

the freedom to contract in this way and cracks will occur at the points between the indentations. This will happen even when it is possible to lift a sheet of glass vertically from the mould. This problem can be overcome by a number of means.

If the indentations are not too severe the glass can be released vertically at a time when it has not completely shrunk back. This can be effected by opening the kiln at 150°C (302°F) and lifting the sheet from the mould with asbestos gloves and turning it over.

If the trapping is severe, the mould itself can be sectioned, leaving expansion joints to allow for movement (figures 95 and 96); these joints should be made along the stress points of the mould (a line midway between indentations). The likely materials for this type of mould are plaster or ceramic type mixes; it is therefore possible to make the mould as a total cast unit, and to section it by cutting with a bandsaw. When the mould is placed in the kiln the gaps made by the saw blade can be filled with dry plaster or ceramic fibre paper to prevent them from showing on the glass surface. This trapping problem obviously does not occur with granular bed moulds like dry plaster or sand.

It is only necessary to be this careful with castable moulds when the depressions are numerous and steep, as calcined materials will give more than steel. If a cast mould is required for multiple use, expansion joints make glass removal easier and therefore the mould takes less punishment.

Any material which is inert at 800°C (1472°F) and which will, or which can be made to separate from the glass can be used to provide the basis for pattern or texture. In addition, castable materials can be used to take the impression of materials which cannot take firing temperature, wood, string, plants, etc., (figures 97 and 98). Metal sheets, rods and wires can be used providing they are coated with separators. Wire itself offers possibilities because of its physical form. Most wires can be fused into glass, onto its surface, or removed after firing leaving a fine line. Copper is particularly good in this way as it oxidises and

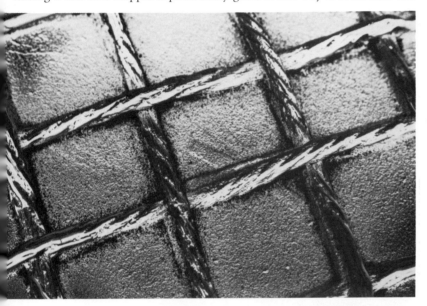

97 A cast taken from string to show the detail possible with this process.

98 Detail of a cast pattern. The original was a paper collage which has been reproduced via the mould on a surface of the finished piece (an ingot casting).

99 *Above* An internal pattern created by copper wire. Copper wires (the circles in the photograph) are embedded into laminations of sheet glass. When fused, the laminations distort around the copper wire which remains rigid.

100 *Above right* A sheet of copper with small pieces of sheet glass fused to cover its entire surface. The variations in colour are caused by uneven oxidisation of the copper during firing.

creates a layer between it and the glass which facilitates removal. Commercial wired glass (figures 99 and 100) has chromium plated wire embedded between two soft sheets. The chromium creates a layer between the glass and the wire core which reduces stress in the final sheet.

Ceramic fibre papers and compressed boards offer a wide variety of forms for kiln use. At its thinnest, 0·5 mm ($\frac{1}{32}$ in), it is similar in consistency to blotting paper and can be torn or cut with ease into complex shapes. A fusing bed can be made wholly or partly from it and complex layer effects can be achieved with it (figure 101). It is soft, easily damaged and expensive. It imparts specific textural qualities to the glass and makes a direct collage approach to mould making possible. A limited number of impressions can be taken from it providing it is left undisturbed in the kiln inbetween firings.

Mould materials have been discussed so far in terms of the visual qualities which the various fabrics impart to the glass or the shapes which their use makes possible. They can be loosely separated into single firing, limited repeat firing or multi-firing types and they are categorised and described in a separate section.

Fusing is a complex process and problems vary with each firing and the specific relationship of sizes and weights of glass used. An example will suffice to demonstrate the subtlety of these relationships. Take a small sheet of window glass and crush a small piece of it to very fine powder form (100 mesh); it would be logical to presume that the granules would be compatible with the parent sheet. In fact the individual granules would each act as separate pieces and in fusing to the parent sheet and each other would create different rates of shrinkage. This is on account of their extreme relative mass in relation to the sheet. A way of overcoming this is to mix a small amount of soft flux to the powder to restore its shrinkage rate to near that of the parent sheet.

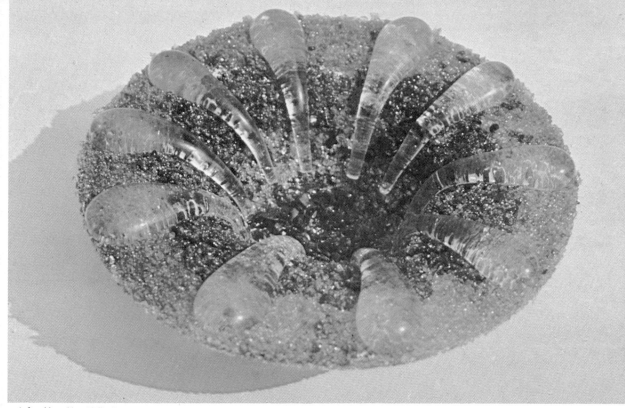

5 A fused bowl by Clifford Gomersall – a mix of crushed glasses and trails made from hot glass

6 Cane amalgams: kiln fusions of pulled rod sections, sawn and polished for mosaic inlay work

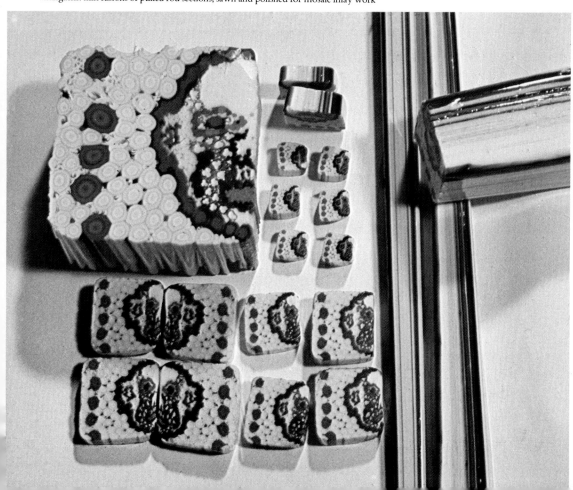

7 Sections from a copper foil core filled with random glass fragments

8 A vertical section through a form made by pouring a number of crucibles separately into a mould

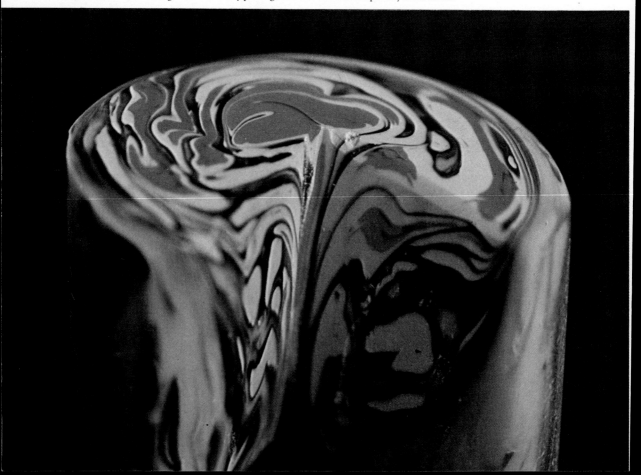

101a Detail of a ceramic fibre mould made to show the variety of qualities and levels possible with this easily worked material.

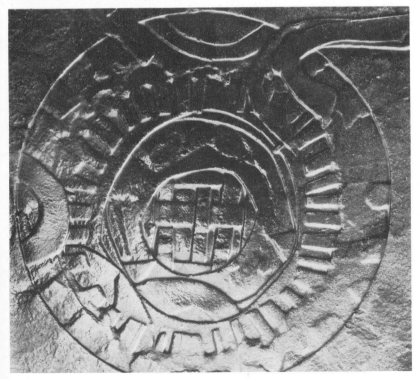

101b A glass cast taken from this mould shows that subtleties of surface have not been lost; the difference between torn, cut or interwoven areas can be clearly seen.

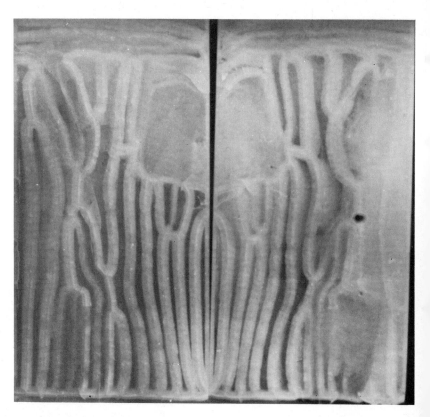

102 A block produced by fusing small pieces of ordinary sheet glass together to high temperature and sawn in half to expose the striations. Each piece was dusted with enamel to emphasise the different components.

Laminations

So far we have discussed the fusing of small pieces of glass into larger wholes. By fusing sheets of the same size on top of one another laminated sheets can be created. This process, which is really large scale fusing, has several areas of possibility for form and decoration and several problems which are specific to it. Laying large, flat sheets of glass on top of one another in a kiln and fusing them together creates areas of heat imbalance between glass on the extremity and the glass in the middle of the pile. This can cause movement of the sheet as the strain releases itself in the form of quite dramatic cracking.

The way round this is similar to creating mould clearance in sagging, to incorporate small glass spacers at the extreme corners of each sheet. This has the effect of lifting each piece clear of the one below it and allowing a more even heat absorption. Fusing large sheets from small pieces is a quicker process because the temperature gradient can be very steep. Sheet lamination on the other hand needs to be carried out very slowly for the first 300°C (572°F).

Lamination can be employed to create large thick sheets of glass or to create rich cross-sections where the build up of sheets is evident, but it can also be used to include materials inbetween sheets and create trapped layers (figure 102).

Inclusions

It is of course possible to use conventional decorative materials for lamination, particularly enamels and glass powders. These must be free from any medium which will carbonise, so that dry powdered enamel is best. This can be sprinkled or painted using distilled water as a medium. Either 540° or 710°C (1004° or

1310°F) firing range enamels can be used for this purpose. Many other materials can be trapped, some of which are not conventional, in fact this is one area where experiment can yield unexpected results (figures 103 and 104).

Metals, in powder, foil or wire form can be used. The easiest and most predictable being copper foil and wire and nichrome wire. If copper foil is laminated between sheets it will not receive enough air to oxidise it completely during firing and the result will be a very rich red inclusion in the glass.

If a copper foil sheet is used that has indentations or surface texture, shallow depressions can be sand blasted into the glass sheets to take the copper and allow for its extra thickness. In this way the sheets of glass will still fit flush together whilst firing and enable the copper to be fired under more or less reduction conditions and retain its red colour. Other metal foils can be used providing that they are thin enough to allow the glass to move even if it wets the surface of the metal. They will all oxidise to a certain extent with the exception of gold foil which is the most ancient of the inclusions.

103 An experiment by Rob Fisher: sheets of plate glass fused together with powdered enamels trapped between each sheet. The resulting block has been sawn into sections.

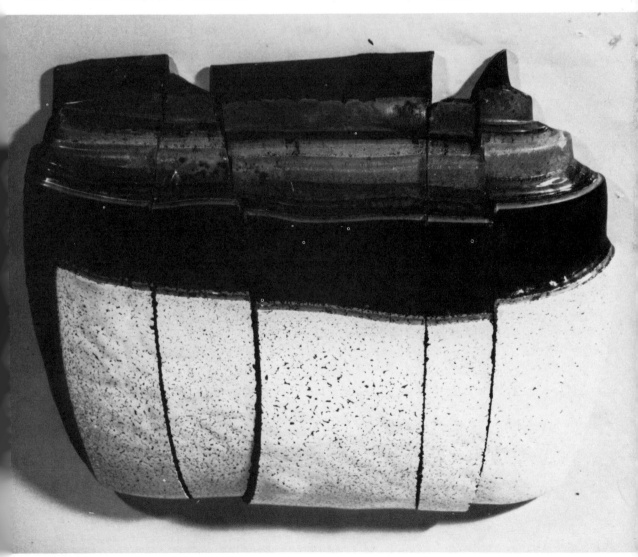

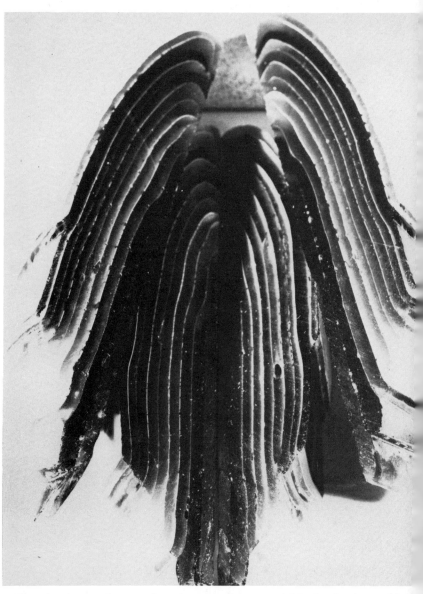

Fibreglass in strand or mat form is an excellent material for lamination and it can be used with enamels. The resin binder which is present in fibreglass must be allowed to burn off, but the suggested use of heat spacers should also allow this to happen, for by the time the top sheet softens onto the under sheet the resin will have disappeared. It will also mean that the glass will join from the middle outwards and avoid air trapping.

Many other materials can be used and experimented with, from simple ceramic glaze oxides to organic materials like leaves, twigs, etc. These will carbonise and the trapped traces are often very beautiful.

French chalk or talc can be used to coat the sheets in a laminated sag forming where they would prevent the sheets from sticking together and make it possible to produce a number of identical sheets over one mould in the same firing.

105 A panel by Alison Roberts, in which an etched copper sheet has been fused between sheets of glass.

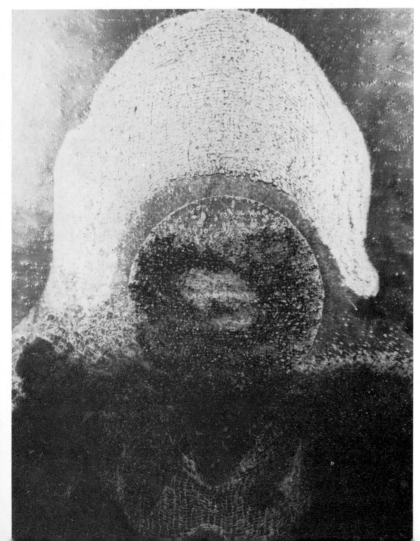

106 An enamelled piece by Mark Chappell, in which the enamel has been trapped between glass sheets and fused.

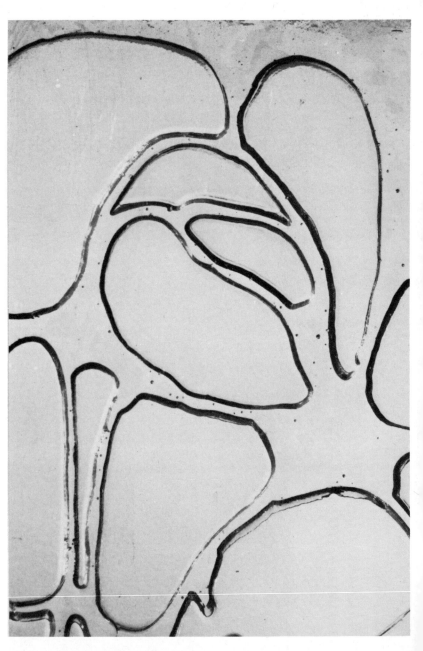

107 Air trapping: an accurate pattern of bubbles has been established in this panel by sand blasting a sheet of glass right through and trapping it between two sheets of glass during firing.

Air can be trapped deliberately and in a controlled way in laminations. This can be done by creating pockets of air prior to firing (figure 107), made by sand-blasting, drilling or arranging cut pieces. The rule is that an area of continuous glass must surround the air in order to trap it. In this way, when the sheets fuse, the air will be sealed in, and if the temperature is high enough the air will be allowed to expand by the softness of the glass, and this expansion will cause an increase in the size of the bubble and a stretching of the glass which restricts it. Materials can be introduced which will gas at certain temperatures and, once they are sealed, produce less controlled bubbling. Ordinary washing soda is the most easily obtained for this purpose.

Temporary fixing

Sometimes it is impossible to place glass in the correct position for fusing without some kind of glue which will hold the glass in position until fusing occurs and then conveniently fade away leaving no trace. Almost any organic glue will suffice but gum arabic is the simplest. Used thickly but in small areas right at the edges of the piece to be joined; this is to allow it to burn off once its job is done. If even a small amount is trapped it can cause a black scar within the glass.

Glass soldering

Fusing involves some exchange or flow from one piece of glass to another. If this does not happen then an inefficient weld is created. Good fusing involves fairly high temperatures and a corresponding softening of form in the glass. This is limiting, so if a crisper form is required with minimum deformation of the glass elements, or if glasses with different compatibilities must be joined, then a glass solder can be used. The principle is exactly the same as employing soft metal solders to join metals together by capillary joints rather than welds. As with such metal joints, their mechanical strength is poor in comparison to fused joints. However, if used in fragile structures where no great weights are involved they can be effective.

A glass solder is a soft glass (or mixture of glasses) which has a flow point much lower than that of the glasses to be joined. It can be used in powder or granule form and is placed between the pieces of glass to be joined to cover only those areas where the glasses will touch. The temperature reached will be the fluxing point of the solder as a minimum (540°C (1004°F) in the case of our examples) but it can be exceeded safely to allow sagging of the sheet glasses. The result is that the solder glass will flow and stick to the surfaces of the adjacent glasses creating a joint, at the same time keeping them apart. Clear glass enamel, enamel flux, or clear crinkle enamel all make good fluxing solders.

When applied well it is almost invisible, and is an elegant way of utilising and exploiting the different relative viscosities of different types of glass.

Forming glass by suspension

So far we have discussed glass forming by total sagging onto a mould, supporting it over its entire surface or partial support, that is retaining the flat identity of the glass sheet in part and in part allowing free-fall in areas which are unsupported. The third category is to suspend, rather than support, the glass in small specific areas, usually through holes in the glass (figure 108). The resulting form is an interplay between suspension points, gravity and the relative weight/elasticity of the hot glass.

This is a different way of working from the other two categories in that a mould as such does not exist, and the family of forms which result from such activities are freer and owe much more to the unique qualities of glass, in fact they are unthinkable in any other material. They require a correspondingly high level of predictive control and experience in the manipulator. In terms of material use the nearest analogy to this method is the weighting of sheet rubber and textiles which have been restrained at certain points. The engineer Frei Otto (whose book, *Pneumatic Structures*, is a useful source book for kiln working) and the architect Gaudi both employed these methods in the generation of forms for their structures. The difference is that it is possible to freeze glass once it has been tensioned.

108 *Above* A suspended and
enamelled piece, undertaken as an
introductory exercise.

There is one great constant force in this kind of kiln work, the intractable
action of gravity with its constant unchanging vertical axis. A sheet of glass
suspended horizontally in a kiln will react in a very different way to one
suspended vertically. It is even more important to spend time with a spirit level
establishing the horizontals of the kiln and the supporting structures than with
the earlier methods. The main kiln devices will be made from metals, involving
chain, wire, rods. The glass will be suspended, balanced on the forming device,
or be suspended above a former in a two-part operation. The points of contact
between glass and metal are important for two reasons.

Firstly, at these temperatures the glass will bond to the metal and create stress,
so that separators must be incorporated into the structure at glass/metal joints,
or the metals used must be compatible with the glass.

Secondly the areas of contact are the suspension points, and their size, number
and position will cause the deformation of the glass in very specific ways. Their
precise form is as crucial a design decision as the shape of the glass. Suspension
then involves restraining the glass at certain fixed points either by drilling holes,
attaching pegs or wires or by creating ridges or other keys to provide fixing
purchase. If holes are drilled for this purpose they create weaknesses which will
have a decisive influence on the final form, for stretching occurs most round
these points and a 5 mm ($\frac{1}{4}$ in) hole can become a 150 mm (6 in) slot in the
finished piece (figure 109).

The alternative to suspension is balancing the glass on a frame around which it
will deform as it softens (figures 110a and b). The advantage of this is that you do
not create weaknesses or stretch points to begin with and the sheet of glass can be
left untouched by holes or key points. The usual material for this kind of
support is metal, usually rods of varying diameters. If the glass is expected to
drape around such a structure in its forming, it is necessary to build flexibility
into the structure to allow for contraction of the glass and to facilitate removal
from the glass, piece by piece. Any metal surfaces likely to come in contact with
the glass must be well covered with some kind of separator, not only to prevent
sticking but also to make them loose enough to slide away from the glass should

109 *Above right* A detail of a
suspended piece showing the
distortion of small drilled holes
during firing.

it wrap around them. This can be achieved by a thick coat of emulsion paint or a wraparound covering of copper-foil or ceramic fibre paper.

The difference between suspension and balance forming rather than mould bending is that the frame or suspension points are the starting configurations from which or over which the glass forms itself. In bending the mould is the end of the process not the beginning.

The monitoring of this kind of work is more acute than with other kiln methods. The dramatic speeding up of deformation within a small temperature increase has already been mentioned. It is a much more important consideration in processes where the weight of the glass plays such an important role by exerting pull on the increasing elasticity of the glass. This is the visual process at its most extreme. Once the desired form has been achieved it is advisable to lower the temperature by 50°C (122°F) rapidly (opening the kiln door) to freeze the form and prevent further movement. This is in addition to switching off the kiln which one would normally do with all kiln processes until annealing temperature is reached.

So far suspension and balance have been described in terms of sheet glass. However these can be varied by altering the sheet; by drilling, sawing or sand blasting areas, its deformation can be altered. Weights can also be used to affect the gravity/weight equation by increasing the weight of the glass at certain points. This can be done by adding glass (fusing) or actually hanging weights on wires (figures 111a and b, and 112).

Three dimensional forms also provide good starting points, particularly blown glass containers. Whether they are everyday packaging bottles or specially made for the kiln, their container forms make them ideal for holding weights, particularly in the form of materials like sand or plaster which will not stick to the glass and can be removed afterwards. Granular materials will move with the glass as it shapes (see figure 113), and in addition to the more obvious materials experiments can be carried out with a variety of unlikely ones.

A variation of suspension or balancing which is flexible and subtle is the creation of structures which move at a certain point in the forming cycle and

110a *Left* The first stage in the production of a sagged piece: the glass sheet is placed over a mould of plaster, steel and ceramic fibre paper.

110b *Above* The second stage: the glass has sagged and folded over the former. The softness of the ceramic fibre paper has given enough room for contraction and makes it possible to remove the glass.

111a *Above* The first stage in the production of a suspended form (by Paul Hughes): the sheet of glass, with cut decoration, is fixed to the frame in the kiln on steel pegs wired to the top of the frame.

111b *Above right* The second stage showing the finished form: the firing has polished cuts which were in the sheet.

112 A suspended piece in 12 mm ($\frac{1}{2}$ in) glass by Yolanda Teuten. The glass sheet was weakened by concentric drilling to half its thickness, then frame suspended with glass weights attached by wires to create selective distortion when the glass softened in the kiln.

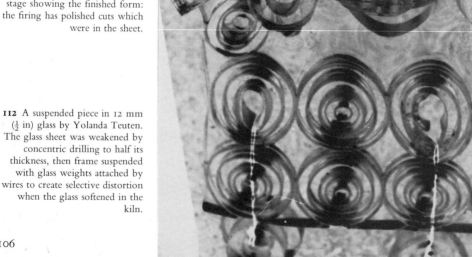

affect the shaping of the glass. The movement of the glass can act as a trigger, so that chains may be kept apart by a rigid sheet of glass which, when soft, will sag and allow the chains to move (figures 114, and 115a and b).

On the other hand a structure can be manipulated by opening the kiln and physically adjusting it (figures 116 and 117). This kind of activity seems to me to express the unique qualities of kiln worked glass in its highest form by exploiting glass through prediction and selection within the repertoire of glass.

A variation can be achieved by using glass to prop or suspend glass rather than other materials. In this way both the support glass and the supported will deform although at different rates because of the disposition of compression and tension, unlike the use of wire or metal sheet which will remain as constants. The glass structure will also fuse together creating a new unity into which is built a diagram of the stretching and squashing forces which have acted on the glass forms.

113 Kiln exercises invloving small blown forms filled with various materials and suspended.

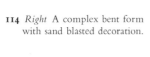

114 *Right* A complex bent form with sand blasted decoration.

115a *Above right* In the background is the first stage: the flat sheet, sand blasted and wired ready for suspension (with a previously fired piece in the foreground).

115b *Above* The second stage: a piece in the kiln showing that the form is the result of suspension on chain, to allow movement, and sagging over metal formers.

116 *Right* Detail of 'Wave Form' by Jane Hill. This sheet of glass was deformed in two stages on a pivoted frame. The basic sagged form was created with the frame in a horizontal position and then angled to distort the regular curves.

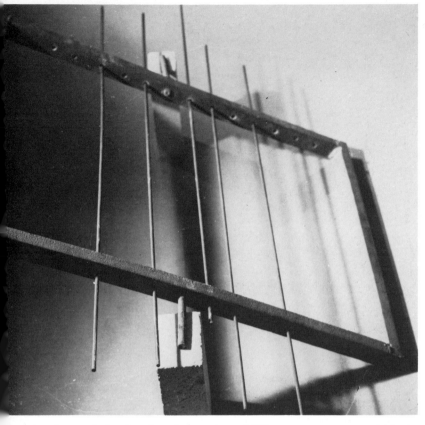

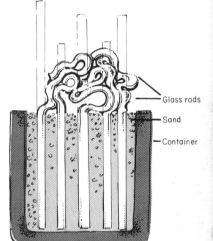

Glass rods

Sand

Container

Another variation involves the creation of different temperatures within the same structure; in this way it is possible to obtain within the form areas of different viscosities, so that one area of glass may remain unaffected while others are totally heat deformed. This can be done by employing refractory materials, bricks, kiln furniture, sand etc., not only to support the individual pieces of glass but to shield them partially from the heat of the elements. In this way a piece of sheet glass placed between two refractory bricks with some of its area protruding would have the sandwiched area supported to prevent its sagging and also be maintained at a lower temperature.

A very effective method is to embed glass components within a container (which may be a simple tin can or a custom built ceramic form) and packed to certain depths with sand or vermiculite particles (figure 118). This has the advantage of allowing each individual piece of glass to move. This movement is essential where individual pieces are to be fused and yet remain independent. This is because at one point the separate pieces will be fused into, and act as, a single unit during cooling/contraction, and unless it is capable of taking the still separate pieces with it in its contraction there will be fractures across the two areas. This is also true when a preformed glass component is included in a mould to be picked up and incorporated into a new glass object during a second firing. It is essential that the preformed component can move with the piece to which it has become attached. Either the mould must be soft enough to allow this movement or an enclave must be made within the mould to receive the preformed piece, and it must be packed into this with a granular material like sand.

118 *Above* This exercise serves to illustrate a basic principle of kiln working. If glass is exposed to heat equally it will deform equally. If parts of it are shielded, different rates of deformation can be achieved within the same piece. Here glass rods are embedded in sand in a container. On heating, the exposed sections react to the heat whilst those in the sand are (a) unable to do so, and (b) less likely to be at deforming temperature. It also meets another important condition; the sand by its granular construction allows the individual glass pieces to move independently as cooling and contracting occurs, thus safeguarding the wholeness of the form.

Flow level techniques

The following processes make use of the liquid qualities of soft glass where it runs to fill the space alloted to it. Once again precedents are to be found in the work and writings of Mesopotamian workers. They identified this viscosity level as that of 'coiling like a snake' when poured from a gathering device.

High temperature fusing

Pieces of glass fused together at a temperature in excess of 800°C (1472°F) lose their identity and shape. They flow until their movement is arrested by another piece. Unless the pieces are coloured or separated by a layer of enamel, the boundary line between each piece will disappear.

Creating solid forms with coloured sections

The raw materials for this method of working are: moulds of plaster, copper foil, silver sand, saggers, glass powder, grain and lump, rods, singly, sections or pre-drawn bundles.

The simplest method, and it is one which is till practised in Africa to produce glass tube beads from cane fragments, is to make a plaster and sand mix slab, drill holes in it and fill each hole with glass pieces. In this way each hole becomes the mould for that bead and the diameter of the hole determines the diameter of the bead. The slab is then fired to a temperature in excess of 800°C (1472°F). The result will be solid rods of glass with random internal sections caused by the fusing of the different glass elements into one another (figure 119).

The main qualities created by this method are the fortuitous and un-controlled internal patterns within the solid lumps. These can be cut and polished like natural stones, or sectioned for further kiln use.

In bead production a copper tube or heavy wire can be embedded centrally in the mould. This can be removed after firing by stretching, and creates a hole for stringing.

The more controlled version of this method is much closer to cane-sectioned (millefiore) work and consists of building a number of canes vertically into a mould so that their cross section creates a specific pattern. The pattern and its complexity are determined by the diameter of the rods, and these can be drawn out fine as needles for the purpose (figures 120 and 121).

It is also possible to use crushed glass to create fairly complex determined cross-sections (as opposed to accidental). The main problem is the refusal of the crushed glass to stay where it is put in vertical configurations. This can be organised in a number of ways, for example by combining cane and crushed glass in the same mould so that the cane creates the shapes which the crushed glass fills, or by making temporary walls within the mould to contain the crushed glasses until the mould is full. This can be done by using stiff paper as

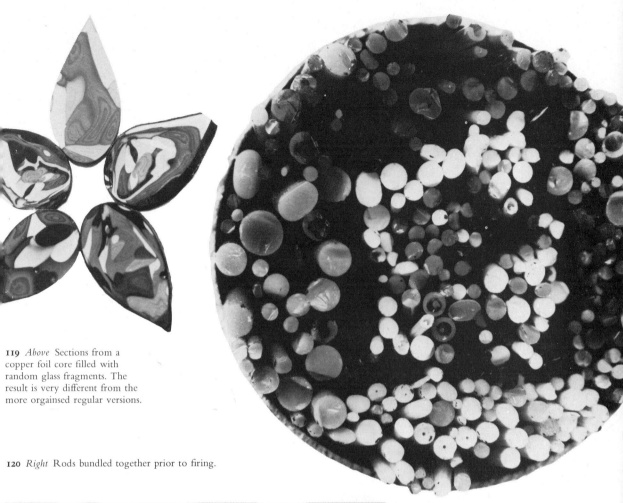

119 *Above* Sections from a copper foil core filled with random glass fragments. The result is very different from the more orgainsed regular versions.

120 *Right* Rods bundled together prior to firing.

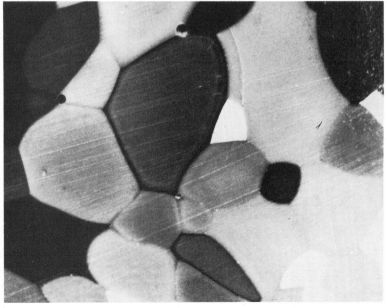

121 A detail of fused canes showing the way in which they melt into one another to create the honeycomb effect.

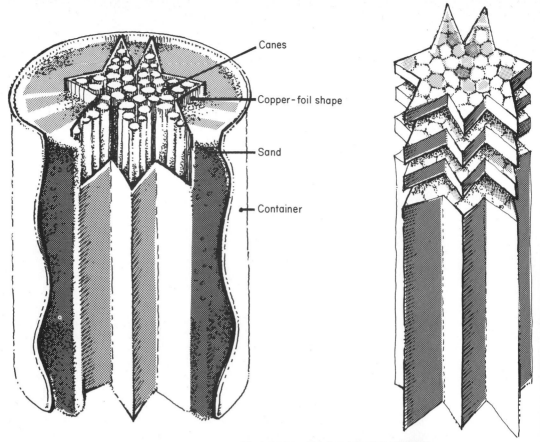

Canes

Copper-foil shape

Sand

Container

122 *Above* A method of producing a solid core made up from bundles of cane to create a patterned cross section. The folded copper foil, in the shape of a star, is filled with cane and fired.

123 *Above right* The copper foil will have fused tightly onto the glass. If required this can be removed by application of dilute nitric acid. The core can be sawn up into thin sections for further kiln work, jewellery applications, or in the glasshouse in conjunction with hot glass or blown forms.

124 An example of the copper foil rod casting method. A copper foil folded shape is shown at the top. The leaves are individual sawn sections from the cast block.

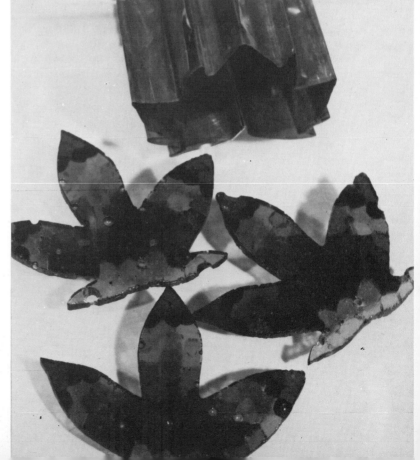

'cloissons', either folded or in combinations. Once the mould has been filled these paper dividing walls can be pulled out from the top and the glass should only settle slightly. The mould could be fired with the paper in position, when it would carbonise and leave a fine black line round each area.

Another method is a variation of these where the role of the card is taken and extended by fine copper foil. Copper in certain forms can be safely fused with or into glass. This method uses copper foil in thicknesses of ·07 mm–·15 mm ($\frac{3}{1000}$–$\frac{6}{1000}$ in) to create the outside shape and to act as dividing walls within the form, usually dividing one colour from another. Unlike the paper 'cloissons', these copper walls remain and become fired in as part of the core. The result is in fact similar to metal enamelling where thin metal cloissons are used to contain enamel during firing and remain to become part of the process. An advantage of this technique is that the foil walls can be used to keep coloured glasses apart which are incompatible and yet combine them in the same form.

Depending on the size of the containers and cores it is possible to make a number in one container, the intervals between them being filled with tightly packed silver sand. These cores are well suited to saw into thin sections for re-fusing but the same technique can be used to create single shallower sectioned forms for use in their own right; this brings it even closer to metal enamelled objects. Such a piece would require to be faced off and polished and could in fact be an amalgam of crushed glass, cane sections, sawn core sections and copper foil.

Figure 122 shows a method for the production of cane cluster sections, i.e. a solid core made up from bundles of cane to create a patterned cross section. Canes of various weights can be used, on their own or in combination with crushed glasses or random sections. A core made by this method can be sawn up into sections of identical patterns. The main difference between such cores and those made by glasshouse methods, i.e. pulling out heated bundles is that the kiln produced versions are not elongated. For this reason the kiln method has a potential for shape control that the glasshouse method lacks.

The principle is to give shape to the core by restricting it inside a folded copper foil exterior, in this case a star. Very complex forms both geometric and free can be made up. The folded copper exterior is placed within a container, this can be either ceramic (sagger) or disposable (large tin). The gap between the container walls and the copper foil are packed with sand to hold the foil rigid. The copper shape is filled with cane, crushed glass, marbles, etc., and fired on a kiln batt to 900°C (1652°F) when the glass will fuse. After firing, the core can be easily pulled from the sand (figure 123).

Pouring

The third stage of viscosity described by the Mesopotamians was that of 'coiling like a snake'. This picturesque description defines the highest temperature level for kiln worked glass when it is soft enough to flow across a surface, or pour through an aperture or from a crucible.

This coiling action is peculiar to glass in the sense that even in its molten state glass has a strong skin at its boundary with the air (a fact that allows such paradoxes as the cutting of a stream of liquid glass with shears). As a result of this skin, when glass coils onto a flat surface which interrupts its flow, the individual coils do not completely homogenise and a visual record of the coiling is left in the glass puddle (figure 125); this visual effect can be heightened by colouring the glass stream (see figure 188). There are a number of ways in which this action of glass can be used.

125 *Above* 'Coiling like a snake': glass which has reached the third stage of viscosity is allowed to pour through a hole, which causes the stream to be circular. When its progress is arrested by a flat surface, the resulting pattern is predictable, and therefore partly under the control of the designer.

126 *Above right* Folding: by forcing the glass to pour through a slot instead of a circular aperture, a continuous sheet of molten glass is created which folds on contact with a flat surface, and an entirely different kind of pattern becomes built into the glass.

127 A kiln packed with empty moulds, with reservoirs positioned above them filled with glass.

Shaping the stream of glass

The form of the aperture will determine the shape of the hot glass stream and will obviously affect its behaviour when it reaches a static surface. It is possible by altering the aperture to make the glass fold instead of coil (figure 126).

The height of the glass reservoir from the surface it flows to is obviously important. The further the stream falls the thinner it will become and the more it will revert to a circular stream of liquid. The thinner it becomes the more intense will be its convolutions when it does reach a surface.

The simplest method is to create a reservoir (ceramic cup, crucible, copper foil cylinder, steel extrusion) to hold the cold glass (the choice of type, whether lump, powder or rod, will affect the flow and pattern), make an aperture in the base of the container, and place this container in a kiln above the surface/mould onto which you want it to fall. On heating the kiln past the flow point of the glass, usually in excess of 850°C (1562°F) the glass will liquidise and pour through the aperture (figure 127). This flow from reservoirs positioned within the kiln can be used in a number of ways:

1 *Collecting in a mould*

The first method is to collect the hot glass stream in a mould placed underneath the aperture at the desired height. This would fill the mould and create a solid glass form with complex internal structures caused by the apertures, their size, shape and number, the number of colours used and their disposition within the reservoirs (figures 128, 129 and 130). A reservoir with coloured glass layered horizontally will produce a differently patterned stream from one packed vertically. This is an effective way of casting solid forms, particularly lost wax moulds (figure 131).

The mould will only fill when it is hot, helping to settle glass into its details, and it will fill from the bottom up causing no air pockets.

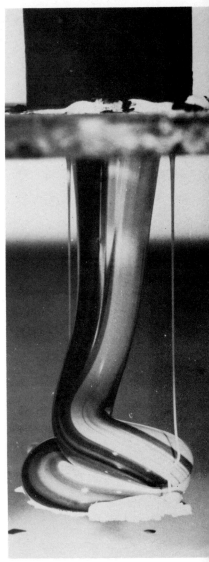

128 *Left* A form created from the pourings of several reservoirs, cut open to reveal its internal layerings.

129 *Above* Where the reservoir is charged with a number of colours the result is parallel lines of colour.

115

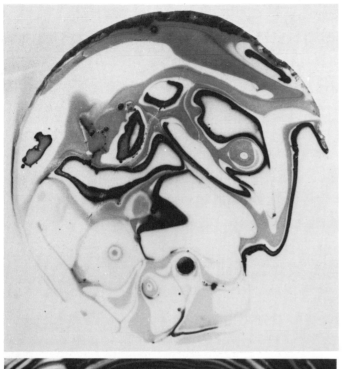

2 Collecting on a flat surface

The second method is to allow the stream of hot glass to collect on a flat prepared surface (figures 132 and 133). The result will be a flat sheet of glass with an even section and fire-polished surface. Its complexities can be varied by having more than one reservoir and a number of apertures from which it will be created.

3 Pouring over a prepared surface

The third method is to cause the stream of glass to pour over or down a prepared surface (see figure 145). If the stream pours over a three dimensional object or down a slope, each coil or fold of the glass will flow down the form it hits and create a pattern of movement as opposed to static or flat pourings. The profiles over or down which the glass flows are all controlled variables which will affect the finished frozen movement that will be recorded in the piece.

Crucible pouring

The introduction of crucibles (figures 134 and 135) brings two new variables into the range of possibilities. Cold glass of a variety of forms is placed in a crucible inside a kiln. When the glass is molten, the kiln is opened and the crucible, manipulated from outside the kiln with tongs, is poured into, over or onto the mould.

The first new element is that instead of the hot glass running through an aperture in the base of its container, it is poured over the lip of the crucible

130 *Above left opposite page* A section of a core which has been made by collecting the flow from several colour reservoirs into a single cylinder mould.

131 *Above right* Two stages of lost wax casting: the figure on the left was modelled in wax, cast in casting mixture and then melted out. The resulting empty mould was placed in a kiln with a full crucible next to it. At high temperature the crucible's load was poured into the mould. The result is seen on the right, as it came out of the mould, before finishing (by Jacqueline Summerfield).

132 *Below left* A pattern created by filling a crucible with different coloured layers and allowing the glass to flow through a hole in its base onto a flat batt positioned below it.

133 *Below right* Detail of a piece created by allowing glass from different reservoirs to flow together into the same mould but from different heights.

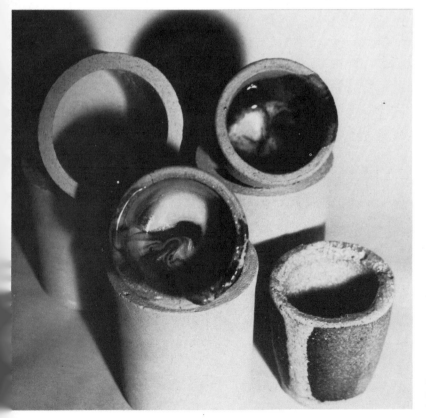

134 Crucibles, fired and unfired: the residue in the used crucibles still shows the contrasting colours used.

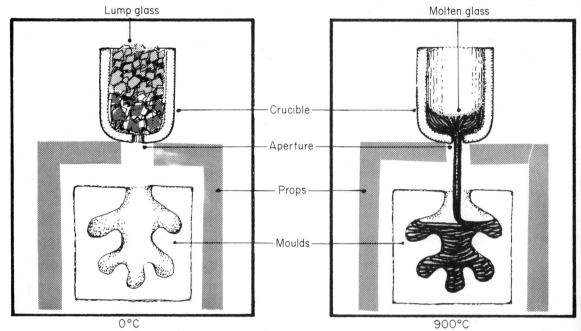

Lump glass

Molten glass

Crucible

Aperture

Props

Moulds

0°C

900°C

135 *Above* Crucible use within kilns: indirect pouring. This involves placing a charged crucible, with an aperture in its base, over an empty mould. The glass particles are too big to fall through the aperture until they have liquidised. The stream of glass will fill the mould from the base up, making air vents unnecessary.

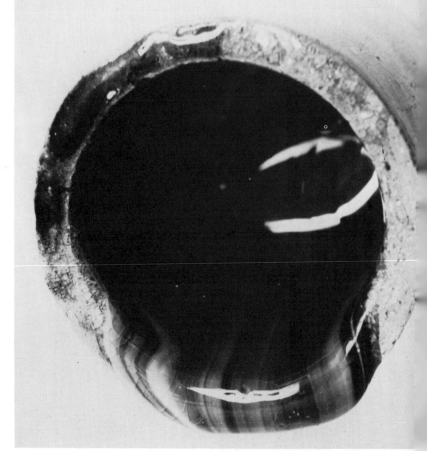

136 Detail of glass pouring over the lip; the effect is that of packed parallel lines of colour which correspond to the number in the crucible.

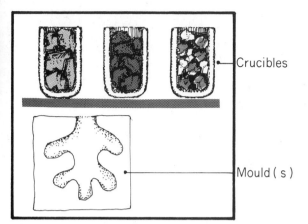

Crucibles

Mould (s)

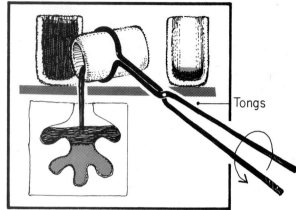

Tongs

(figures 136, 137 and 138). This gives a very different effect from a flowing stream of glass; it is much more like a striped ribbon. The second new element is that the glass reservour (crucible) is no longer static and can be moved about within the kiln with the tongs. This not only opens up possibilities like being able to fill a number of small moulds from one large crucible or fill a large mould from a number of small crucibles; but by adjusting the pouring stream of glass the patterns imparted to the glass sheet, block or shape can be directed and controlled. The glass does not pour when it begins to soften as with reservoir work but only when the crucible is tilted.

137 Direct pouring: this involves placing an empty mould in a kiln with charged crucibles in the same or adjacent kiln. When hot, the crucibles can be manipulated with long-handled tongs to fill the mould. This method enables a selective use of colour by means of separate crucibles.

138 A section cut from a core made by pouring three different crucibles into a mould at the same time.

139 *Opposite* This and the next photograph show two views of the same sheet of glass: the result of a multicolour single-crucible pouring. On the top of the sheet, the surface is fire-polished, and clearly shows the parallel lines of colour.

140 This side shows the reverse of the sheet where the hot glass has come into contact with the mould into which it was poured.

It is possible to vary the quality of the pouring by selecting the temperature at which to carry it out (figures 139 to 142). Lower temperature pourings, at 850°–900°C (1562°–1652°F), will be of an even ribbon of striped glass, the stripes representing the colours present in the crucible, higher temperature pourings, at 950°C (1742°F) and above will be increasingly more liquid with the glass flowing from the crucible as a uniform but more amorphous mass.

141 *Right* A sheet which has been poured from a multicolour single crucible but at a much higher temperature. The result is that the colours have mixed to a much higher degree and have not poured in an accurate ribbon over the lip of the crucible.

142 A high temperature crucible pouring.

Once the pattern is imparted to the glass, of pouring, flowing or folding, the piece can be sagged or bent without too much distortion of these patterns. This may be necessary where the pattern is of the displacement type (figures 143 and 144) which can only be made over a curved or canted surface but which is required in a flat sheet, and would therefore have to be produced in two stages.

143 A vertical section through a form made by pouring a number of crucibles separately into a mould.

144 A kiln packed ready for a crucible pouring. Two crucibles, charged with glass lumps, are placed next to an empty mould ready for pouring at high temperature.

145 The stages and variations in a reservoir casting: a cast iron mould is used as a form for the glass to pour over. As a result there will be shifts in the streams of glasses. Metal mesh is used to support the glass above the mould.

146 The glass can be placed separately in reservoirs, ceramic or (as here) copper foil.

The most dramatic and obvious way of delineating the various movements of the molten glass is to use coloured glasses to create the variegated streams and ribbons of glass. Rich results can be obtained by the use of laminations of clear sheet glass and enamels as reservoir or crucible fillers. The results have a characteristic layered quality. Figures 145 to 151 show the stages and variations in reservoir casting using a metal mesh to suspend the reservoirs of glass over the former.

147 If they are placed in
reservoirs the glasses will only
mix when they reach the former.
This example was stopped before
complete amalgamation to
demonstrate the separate nature of
the colours.

148 Here the glass lumps are
placed freely together: as a result
they will mix together during and
after dripping through the mesh.
The result is therefore softer and
denser in pattern.

149 Here copper foil tubes have
been filled with layers of different
colour: this gives a different effect
when the multicoloured but
separate streams meet.

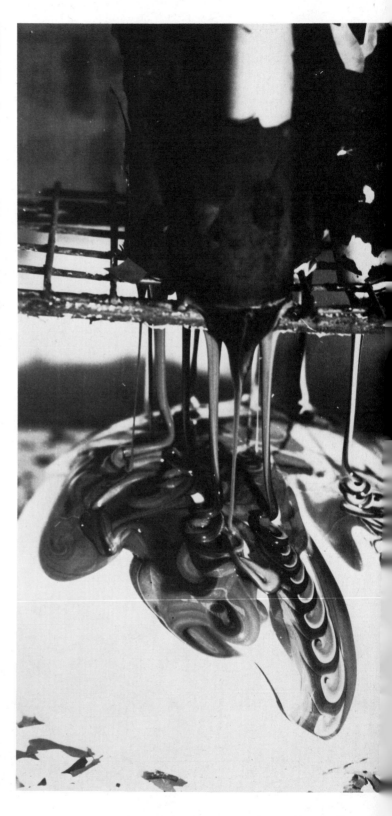

150 Detail of the multicoloured
streams meeting.

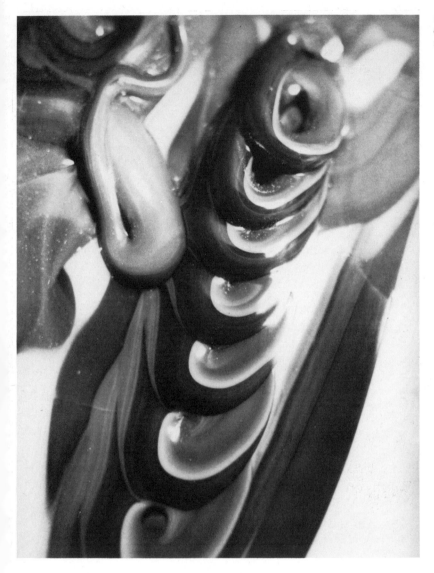

151 A close up of the streams of colours forming over the mould.

152 To produce a form on the principle of folding, a reservoir containing small pieces of glass is set up above a sloped ceramic batt.

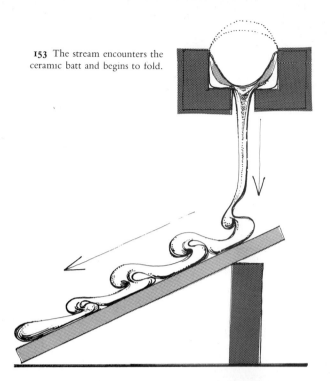

153 The stream encounters the ceramic batt and begins to fold.

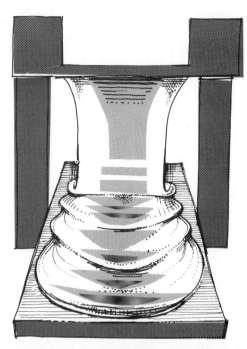

154 *Above right* The resulting sheet of glass has multicoloured folds and a well controlled shape.

155a Folded ceramic paper is used to create a wall to shape the form. The last thread of glass is seen pouring from the ceramic reservoir placed above it.

Figures 152 to 155 show the production of a glass form using the basic principle of folding described earlier. A reservoir, in this case a ceramic box with a narrow slit along its length, is set up above a sloped ceramic batt, and small pieces of glass are placed in the reservoir with different colours placed carefully in areas to determine the disposition of pattern in the sheet of molten glass which will pour out through the slit (figure 152). As the stream flows out, at 850°C (1562°F) it encounters the ceramic batt and begins to fold. Because of the slope it flows down after folding. The folds in figure 153 are simplified, actual folds would number hundreds.

The result is a sheet of glass with multicoloured folds and a well controlled shape (figure 154). In the example shown in figure 155a folded ceramic paper

155b A kiln produced form, by the author.

was used to create a wall mould on the batt to shape the flow of glass. Apart from a shallow facet taken along the base to expose the interior folds, this piece is exactly as it came from the kiln (figure 155b). The manufacture of this object illustrates just one of the ways of employing basic glass behaviour in a creative way. Different kinds of reservoirs, arrangements of colour, formers over which the glass flows into or over are just some of the areas of personal choice and manipulation.

Many analogies can be drawn between the behaviour of flowing glass and the behaviour of liquids in other situations in waterfalls, whirlpools, rapids and other natural phenomena, and as such they can form useful sources of inspiration and ideas for this kind of kiln work.

Moulds and separators

Dry separators

Virtually any powdered material which is inert at the fabrication temperature can be used as a separator or layer between the glass and the mould where the mould would otherwise stick to the soft glass and prevent release. Talc, french chalk, plaster, magnesium carbonate are the most common. The finer the mesh size the softer and finer the finish imparted to the glass.

The separator is applied to any horizontal surface by dusting through a fine sieve. It is often better to do this once the mould is in position in the kiln but before the glass is added. On angled surfaces the mould must be wet to enable adhesion; this can be done by spraying the mould with a fine mist of water or very fine oil.

The function of the separator is to create a surface barrier between glass and mould material where this does not automatically release from the glass. A further function is to impart a texture to the glass by its granular build up on the mould's surface and which the soft glass will accept. The mobile qualities of such layers help to prevent mould pinching and trapping, by preventing mould/glass contact and by shrinking with the glass as it cools.

Wet separators

The separator is suspended in a liquid (water, alcohol) which acts as a medium to aid the application of the separator to the mould and then takes no further part. The suspension of separators in liquids means that they can be sprayed or painted onto the moulds' surface; as a result a finer finish can be achieved and difficult surfaces can be covered which are not accessible to sieving. It is of course possible to combine dry and wet applications for textural purposes.

The main materials for wet application are: talc, french chalk, graphite, white emulsion paint (not vinyl). French chalk and talc can both be mixed with water and painted or sprayed onto a mould. In the case of ceramic or other porous moulds a fine finish can be achieved by first heating the mould to 100°C (212°F) and spraying or painting a very wet solution (about the consistency of milk) onto the warm surface. The water will evaporate and leave a fine deposit of powder on the surface.

Graphite in water or alcohol is a good separator for low temperature slumping but in excess of 600°C (1112°F) it rapidly burns away leaving the mould surface exposed. The graphite pastes which are sold to polish domestic casti-iron fire hearths is rather more durable. This can be applied by a brush, like boot polish, and buffed to a fine surface with a cloth when dry. Even this will burn off at orange heat and it is necessary to add three layers, drying each layer before adding the next to make sure.

White emulsion paint of the traditional kind is an excellent separator for

bending temperature work and it is very suitable for coating metal moulds by painting or spraying. It adheres well to most mould materials. At temperatures above 700°C (1292°F) it can cause bubbling of the softened glass.

Bending and casting moulds

There are two methods of mould manufacture: casting and construction. There are also three kinds of mould: one-trip, limited series and semi-permanent.

Castable moulds

This involves casting the mould from a liquid mix which hardens for use. A wide variety of materials, from plaster to casting iron, can form cast moulds, and all three kinds of mould can be made from them. There are general mixes for non-specific use, and highly complex specials which have been devised for unique purposes. Two examples of this kind of mix are those devised by Frederick Carder for lost-wax casting and the nineteenth-century French artist, Argy Rousseau, for his pâte-de-verre work.

This chapter describes the nature and functions of a number of general mould mixes which will establish a basis for the evolution of specific mixes by empirical methods.

Plaster

Plaster is easy to use and cheap, but on its own it cracks and deforms at high temperature. Above 700°C (1292°F) it will stick to and mark glass formed in or over it. Plaster can however form the basis for sagging, bending, fusing or casting moulds by modification. The main difficulty is shrinkage of the rigid plaster structure under heat. The solution is to add to the basic plaster inert substances which are less affected by heat and which have low expansion and contraction rates.

There are a number of substances which fulfil this role. Silver sand, crushed ceramics, like high temperature brick aggregates, metal casting investment materials like crystobolite, french chalk and pieces of previously used moulds crushed to powder.

Moulds made from such amalgams are suitable for low temperature bendings and can be made strong enough to survive a number of firings.

Casting mixes for single-trip moulds

1 Suitable for sagging moulds up to 700°C (1292°F):
75% fine casting plaster
25% silver sand (or Fine H.T. aggregate)

2 Suitable for sagging moulds up to 800°C (1472°F) involving texture or carving for the glass to pick up (see figures 156 to 158):
60% plaster
20% silver sand (or H.T. aggregate)
20% previously fired mould broken down to powder

3 Suitable for fusing over 800°C (1472°F) where the glass picks up all the detail of a moulds surface:
45% plaster
45% investment powder (crystobolite)

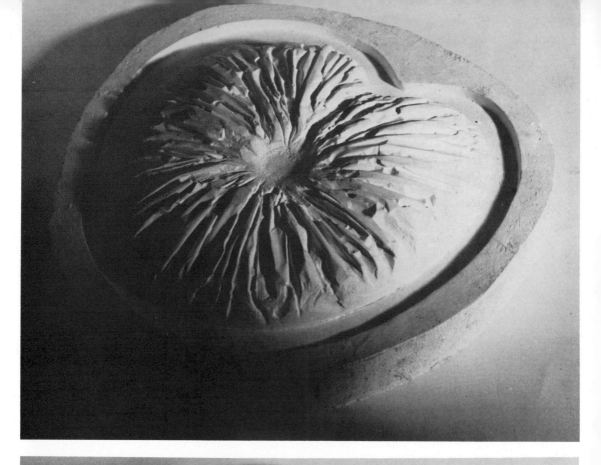
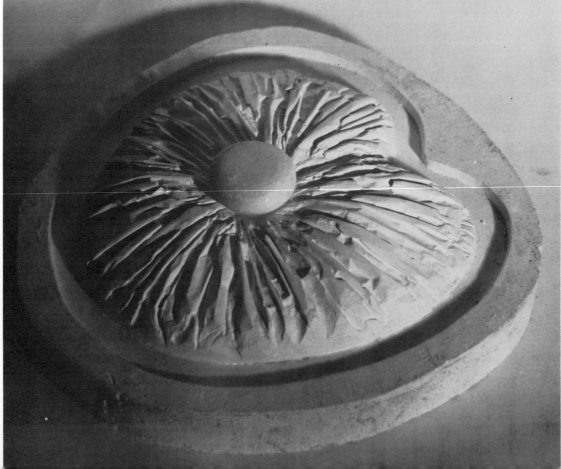

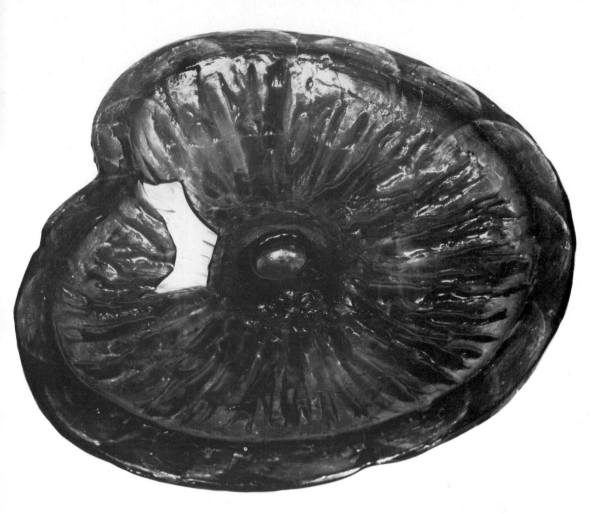

10% previously fired mould broken down to powder

Each one of these mould mixes should be thoroughly but slowly dried out before use. Larger moulds made from these mixes can be strengthened and made more economical by using the basic mix as a face material and backing up with the mix plus H.T. aggregate (crushed high temperature refractory bricks available in fine or coarse particle size).

It is possible to convert the bending mould mixes (1) or (2) to multiple firing quality by adding a thin skin of ceramic mastic (kaowool mastic) applied with a knife to a thin (1 mm ($\frac{1}{16}$ in) is sufficient) layer evenly distributed. When this dries it can be sandpapered to a smooth finish before firing. Take care to wear a dust mask while sandpapering. Such a mould, if carefully used, will accept sagged glass up to 750°C (1382°F) without a separator. A long life can be expected from such a mould especially if it is not moved between firings, either remaining in the kiln or on the same ceramic batt on which it can be removed and replaced.

Permanent cast moulds

These can be cast from specialised castable ceramics developed for furnace and kiln manufacture (figures 159 and 160). The one given below was developed by experimenting with various mixes and is very successful:

156 *Above opposite* The first stage in the manufacture of a fused form, by Denise Lewis. The lip of the cast support mould prevents the glass pieces from moving and helps to create a rim.

157 *Below opposite* The second stage: the mould has a separate element added to create a depression in the centre of the glass form. It is of a softer mix so that it will not crack the glass and can be washed from the glass after fusing; this makes undercutting possible.

158 *Above* The final glass form, fused from separate pieces, shows the rim, the texture of the mould surface and the undercut area in the centre.

159 A permanent sagging mould made from ceramic castables; the rough backing of course and fine aggregates can be seen.

160 A sag mould in a gas kiln after firing. The mould is a permanent ceramic cast. A large high temperature slab has been raised above the burner paths and HT bricks have been used to complete a semi-muffle arrangement (see also figure 72).

Secar 250	H.T. Aggregate – Coarse
Chinese Flint	H.T. Aggregate – Fine

The material is cast as a wet cement into or over a former. This must be the opposite form to the mould required. Vacuum-formed plastic or clay work well as formers for they release easily and impart a high finish to the mould surface, but more rigid materials like wood can be used providing they have a release coat of petroleum jelly on them. Once cast it is allowed to air dry slowly, under a polythene sheet, removed from the former when dry and the surface cleaned up if required. It is then fired to 800°C (1472°F) when it becomes a permanent mould for bending and fusing operations up to 800°C (1472°F). It requires a separator (talc, french chalk, graphite paste). Due to its rigidity care must be taken to section the mould and allow expansion gaps on shapes where trapping is likely.

To apply the mix, a first coat of Secar and Chinese Flint, in a ratio of 1:1 by weight, is mixed dry, and has water added to make a wet but stiffish paste. This face mixture is applied to the surface of the former to a depth of 1 cm ($\frac{3}{8}$ in) or less. When this has been tamped well to remove air bubbles it is backed with a mixture of 1 part Secar, 2 parts H.T. Aggregate Fine, and 2 parts H.T.

Aggregate Coarse by volume. The Aggregate chippings should be dampened prior to their addition to the Secar and the wet mixture should be applied to a total depth of between 2 and 3 cm ($\frac{3}{4}$–$1\frac{1}{8}$ in) depending on the mould area.

For higher temperature work like fusing or hot casting a more sophisticated mould is necessary.

Glass casting moulds

These moulds operate at the top temperature range for kiln worked glass, with temperatures around 900°C (1652°F). The glass in them, whether it is poured from crucibles, run from reservoirs or pre-packed in granule, powder or lump form, is at its most liquid and will therefore fill the mould, completely wetting its surface. It is not possible to make such moulds to function more than once. The mixes are designed to be unaffected by high temperature, to be just hard enough to contain the glass and to be easily removed from it without scarring the surface.

Moulds of this kind made by the lost-wax method make it possible to produce a three-dimensional form in a seamless one-piece mould. It relies on the softness of the mould material to allow movement in the glass as it cools and contracts, and on the fact that such mixes are easy to crumble or wash away from the glass form. The main model for this mixture is the one developed by Frederick Carder for just this purpose. It is still employed by Corning Glass Co for casting one-off specials.

Casting with crushed glass

When constructing and filling a mould with crushed glass for casting a number of considerations are important (figure 161). Firstly, an enormous amount of settling will occur in the glass particles making a large reservoir an essential part of the mould. Secondly, angled air holes must be incorporated to prevent pockets of trapped air into which the glass cannot run. Thirdly, the refractory nature of the mould material makes it necessary to fire to a higher temperature than for crucible casting and to soak for a long time (up to 24 hours) at high temperature to ensure the filling of all details.

161 Constructing and filling a mould with crushed glass, showing the reservoir and air vents.

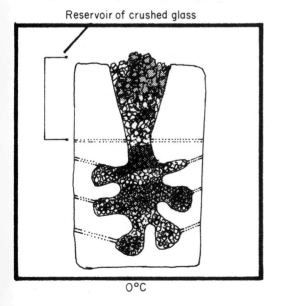

Reservoir of crushed glass

0°C

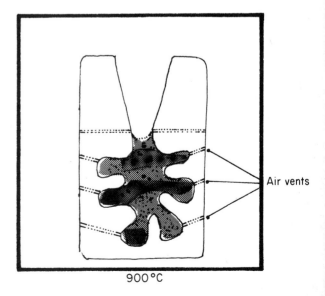

Air vents

900°C

Fusing moulds

These are moulds which operate around 800°C (1472°F) when the glass is soft and mobile and are suitable for fusing and the picking up of texture or pattern from the mould's surface. Forms produced from such moulds are usually fairly shallow and open. Such moulds are more supports for the glass than total enclaves or repositories. It is possible to use plaster as a base material for such moulds, but with inert materials like sand, aggregate or investment providing up to 60% of the mix. The main problem with this temperature range is that the glass is still liquid enough to thoroughly wet the surface and if heavy relief pattern or texture is present in the mould it must be soft enough to release the glass when cold. It is possible for such moulds to operate for a limited number of firings depending on complexity.

Bending moulds

Moulds which operate in the 650°–750°C (1202°–1382°F) temperature band do not have the problem of glass softness to contend with and can be made from a wider range of materials. The main decision which affects the choice of mix and material is whether a mould has to function for one, ten or a hundred firings. (Figures 162 to 166 show the stages in a commercial bending operation to produce one-off or limited series architectural bent sheets).

Simple bending moulds for single firing purposes can be cast from plaster and sand and by the addition of a thin skin of ceramic fibre mastic can be made permanent enough for a dozen firings.

Semi-permanent and permanent moulds can be made from ceramic castables

162 The first stage in a commerical bending operation: the profile is made in wood to act as a former for the plaster bed.

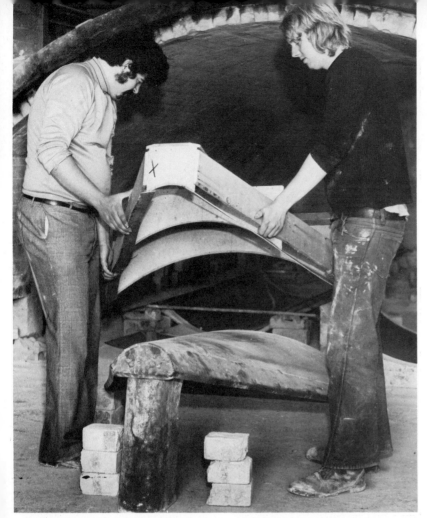

163 The second stage: checking a metal mould with the wooden template from which it was copied.

164 The third stage: positioning the sheet glass in the kiln. The plaster bed has been pressed into shape with the wooden former. The sheet glass is supported above the mould on metal rods. Baffle walls prevent the burners from impinging directly onto the glass.

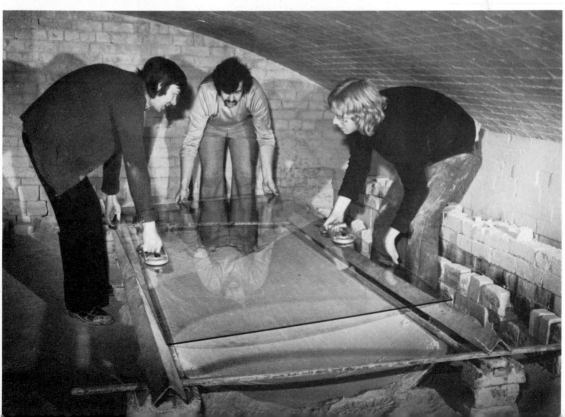

165 The fourth stage: as with smaller kiln operations the actual bending is a visually monitored process.

166 The fifth stage: cleaning the finished sheet.

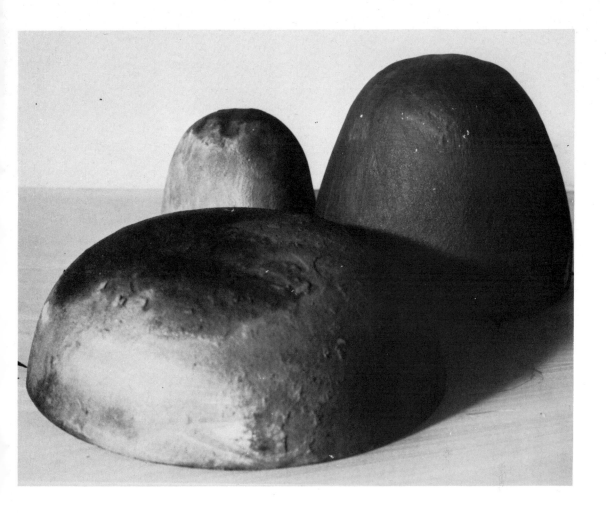

167 Cast-iron moulds.

used to produce special furnace shapes. They can be obtained in a variety of grades and it is possible to cast thin moulds on to a variety of formers (such as clay, plaster, wood and vacuum-formed plastic) with a fine face backed up by rough, strong aggregate cements. These moulds must be fired once to working temperature before use, and must be used with a separator. They are fairly expensive but are virtually indestructable and therefore capable of producing repetitive forms. Permanent bending moulds can be made from cast-iron, particularly simpler forms (figure 167); the originals can be made in plaster or wood and providing they can be cast by direct sand impression at the forming they are a cheap way of making permanent moulds. Their weight and bulk make them heat retentive and they therefore aid annealing. They can be cleaned by wire-brush or sand blasting between firings and re-coated with the separator.

Existing ceramic objects can be used as permanent moulds for bending formers; kiln furniture, batts, props, high temperature bricks are all suitable providing adequate separators are used. Objects like plates, dishes, bowls either bought or made specially, can be used providing any glaze that is used is removed by sand-blasting and a separator applied. Such formers are ideal for repetitive work and because of their availability, for beginners.

168a *Above* A sheet steel sag mould. The oval aperture makes expansion joints unnecessary.

168b *Above right* Dry plaster has been sieved onto the surface to prevent sticking.

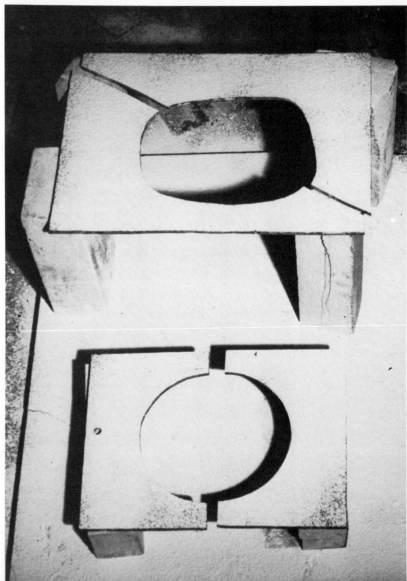

169 Two steel aperture moulds. These have been split to enable very deep forms to be sagged without stress and to make it easy to remove the mould from the finished pieces.

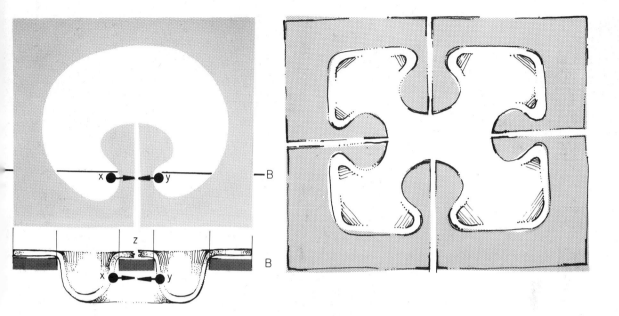

Saggers

Once a mould gets larger than about 8 cm (3 in) it takes up a lot of material. In the case of special mixes this can be expensive in both time and money. One way of reducing this is to make a thin shell of mould material, place it in a slightly larger ceramic container, and fill the gap with sand or vermiculite. This will also prevent mould cracking in high temperature work and, if the sagger is provided with a lid, annealing.

Where this method is not appropriate, as with large bending moulds, metal mesh or ceramic supports can be used to strengthen the bulk of the cast and to cut down on the amount of castable material used. Such moulds can also be strengthened externally by metal mesh supports on the corners and wiring.

Sand

Metal casting or building sand can be used to bend glass over. Curved shop windows were formed by this method as early as the eighteenth century. This is an extension of the use of dry plaster to texture glass, the sand being used to create form rather than texture. Restraining walls of ceramic or metal are shaped to act as a template for the curve and the sand compressed between them (see figure 164). The surface can be smoothed off with a wooden slide. This will provide a good bending bed for simple sheet forms.

Constructed moulds

These are manufactured from metal sheet, rod, wire, tube etc., to bend, suspend or sag glass. Again the main decision is whether a mould is to be temporary or permanent. Short life bending or aperture moulds can be made from thin gauge sheet steel of 2 mm ($\frac{1}{8}$ in) or slightly less but some distortion can be expected. A permanent aperture sag mould should be made from 4 mm ($\frac{3}{16}$ in) sheet steel to avoid warping and to allow for gradual scaling of the metal due to repeated firings (figures 168, 169, 170, 171).

170 *Above left* Plan and cross-section of an aperture, gravity mould, showing the use of expansion joints. The aperture through which the glass must sag is complex and contains a potential trap for the glass across points x and y. The section through A–B shows that when the glass sags through, it expands, and on contracting points x and y will shrink towards one another. If the mould is split in the middle, the pressure at point z will be relieved.

171 *Above* The mould plan would require splitting into four sections, and the gaps would be masked by covering the mould with a sheet of ceramic fibre. If the fibre is protected by a fine sieving of talc or plaster the mould can be used many times. If it is a one-off melt, ceramic fibre paper is probably uneconomic as an all-over covering, but small strips can be inserted into the gaps and an all-over covering of dry plaster put onto it.

172 Detail of glass sheet sagged through expanded metal mesh.

Suspension moulds are usually made of metal and incorporate rigid frames with welded joints and flexible metal/glass supports. All metal moulds must have a coat of separator on any part of a surface which might touch the glass.

Expanded metal sheeting is useful for its flexibility. To create a curved former from sheet steel requires metal rolling equipment but expanded pierced sheet can be bent by hand, and providing it is well supported in the kiln and covered with a layer of ceramic fibre paper, the result can be indentical if less permanent.

Aperture moulds can be made in the same way, that is, well supported and covered with ceramic paper, and will last for a number of firings.

On the other hand expanded metal sheets and meshes offer a variety of surface pattern which can be used to texture sheet glass. Providing the metal is sand-blasted and coated with separator and the glass is only allowed to soften onto it slightly, it will pick up the pattern without trapping the glass and metal together (figure 172).

Special mixes for high temperature casting and pâte-de-verre work

Frederick Carder's mixture *(Reproduced by courtesy of Corning Glass)*

This mixture was developed by Frederick Carder at Corning Glass, USA, to cast his lost-wax sculptures. It is suitable for high temperature casting and crucible-poured work, particularly where fine detail is required. The following proportions are calculated by weight with 170 cubic capacity of water:

100 Plaster
100 Quartz
20 China clay
2 Alumina fibre (Fibre-Frax)
2 Heavy paper

Paper and alumina are liquidised in a domestic blender. The pulp is then poured into a sieve (40 mesh), washed to remove excess paper size and then drained. The other constituents are weighed out and sprinkled onto the water and, when absorbed, the pulp is added and lightly stirred. The constituents are violently mixed with a paint stirrer fitted to a power drill for about 20 seconds. The mix sets off quicker than normal plaster so care must be taken over the timing of this stage.

The wetting agent is sprayed onto the model, and the mix is poured slowly. The mould is gently shaken to cause trapped bubbles to rise through the mixture away from the model. The mould is fired to 800°C (1472°F) unless it is to be used for crucible pouring in which case it becomes unnecessary.

Models of three dimensional forms must be of wax to enable their removal without seaming the mould. If the model is simple in form, e.g. a tile with relief decoration, it can be made from clay as this is flexible enough to remove from the mould mixture. It is however a very soft, easily damaged material, and great care must be taken.

Depending on the shape of the object to be cast, such a mould can be filled in one of three ways.

1 It can be placed in a kiln empty and filled from a crucible. This is suitable for complex three-dimensional forms (see figure 137).

2 It can be filled with crushed glass and fired (see figure 161). This method requires air holes to allow the air to escape as the glass settles; straws placed into the model as the mould is cast work well. It also requires a large reservoir of crushed glass incorporated into the model to counteract the air packed with the granules into the mould.

3 A glass block of roughly equal volume to that of the empty mould can be placed on the mould and fired until the block softens and fills the mould. Once fired the mould material is soft enough to break away easily from the glass. This is suitable only for open moulds.

173 Pâte-de-Verre bowl by Argy
-Rousseau (late nineteenth
century)

Argy-Rousseau's mixture *(Reproduced by courtesy of Corning Glass Museum, NY)*

This mixture was developed by Rousseau to manufacture moulds within which to cast crushed glass objects. As with Carder's mixture and the others in this book, it is plaster-based, and adds materials which render the plaster more inert. Rousseau's mixture is softer and more easily damaged than Carder's.

Plaster	28
Calcined kaolin	22
Kaolin	3
Ground sand	10
Grain sand	37
	100

The plaster must be of fine modelling quality. Calcined kaolin (pre-fired) must be fine, pulverised after firing and must pass through a grade 10 sieve. The unfired kaolin must be sieved through an 80 or 100 mesh. The sand must be silver sand, and the ground sand can be crushed in a pestle and mortar.

The materials must be well mixed and then added to water, allowing the powder to fall onto the surface loosely so that it is thoroughly soaked. Continue adding until it appears just beneath the surface of the water. Mix to the consistency of cream.

Rousseau used this mixture to cast onto rigid models made from plaster and wax, and removed from the hardened mixture in pieces. The mixture is too soft

to use for lost-wax casting. Just as with Carder's mixture it can easily be broken away or even washed from the surface of the glass after firing.

174 Bowl by Emil Gallé (late nineteenth century) cut from a brown blank with applications of fused colour.

A clay mix for small crucibles (Reproduced by courtesy of John Smith)

Bearing in mind the actual application of these small devices, the following fabric provides for an adequate latitude from both points of surface erosion and mechanical strength (see figure 134).

Fundamentally, the fabric is an unresolved stoneware base. The once fired (prior to use) temperature of the 'green' crucibles lie well below that necessary to vitrify or physically consolidate stoneware clays.

To accommodate movement of expansion and contraction, while providing for heat transmission through the fabric when in use, a uniform (grain size) grog material is added to the plastic clay. The inclusion of flint adds considerably to the stability of the clay mix when subjected to heat.

A finely grained plastic stoneware	100 parts
A suitable grog (e.g. 'T' material)	40 parts
Flint (dampened)	10 parts

Thoroughly mix the ingredients together in the plastic state, and form by any method, e.g. using a little water, press moulding, jollying, dry-throwing etc. An optimum section thickness of 1 cm ($\frac{3}{8}$ in) of a cylinder form 8 cm (3 in) high with a diameter of 5 cm (2 in) is recommended. Proportional increase in these dimensions when constructing larger devices is advised. Thoroughly dry the units before pre-firing to 100°C (212°F) prior to using the crucibles for glass melting.

Annealing

The main purpose of this book is to establish some of the prime reasons for employing glass as an expressive medium and to describe some of the main processes by which it can be formed. Its theme has been the vocabulary of heat transformation which is bound up with its rare physical structure, that of a supercooled liquid. Whilst glass is a very technical material in its preparation, its monitoring is often direct and visual. Even in scientific terms George Jones has remarked 'Glass technology has been more empirical than almost any other branch of technology'. Even the most sophisticated manufacturing methods and machinery are still based on the observed and expected behaviour patterns of glass on the simplest level. The mechanisation of glass object production has often been the rationalisation and speeding up of age-old hand methods. Equally the modern monitoring methods are more specific versions of ancient observed glass facts and their control.

One inescapable fact about glass is that as a supercooled or slow motion liquid it acquires stress within its structure during its cooling and hardening to room temperature, and unless this stress is released or reduced to acceptable proportions the glass will crack or shatter. This brittleness is one of the penalties which glass pays for having the open internal structure of a liquid, and as a result offers no resistance to cracks once they have begun.

The strain which causes cracking is in turn caused by imbalances of contraction frozen into the glass; and the release or control of this strain is what annealing is about.

The viscosity levels which are a key part of this book are important in annealing calculations.

At room temperature the tendency of glass to flow has been arrested or slowed down to an infinitesimal rate, the result being that it passes for a solid. On its temperature being raised, it reaches a point at which its tendency to flow increases dramatically. This is called the transformation point, and it is actually a narrow temperature range above which glass behaves like a liquid. Even at its most liquid it is 100 times more viscous (slower to pour) than water. The transformation point (or temperature band) is the barrier between the liquid and solid states. Strain is set up or released as glass passes through this transformation point on its way down to room temperature.

Strain is caused by different parts of the glass being at different temperatures and therefore at different points in their shrinkage cycle (contraction). If the glass passes through the transformation point and solidifies with these imbalances frozen within the form, they will create actual or potential breakage stresses. The release of strain involves the evening out of these stresses by, if possible creating an even temperature throughout the body of the glass and lowering this temperature constantly and evenly.

Toughened glass has artifical strain induced scientifically which creates a delicate balance of strain between the skin of the glass and the interior. This

tension is released during an accident and the controlled explosion results in the fine particles of glass characteristic of toughened glass breakage. It is not possible to create toughening situations in kilns, nor incidentally is it safe to use toughened glass, like car windscreens, in kilns or even use a glass cutter on it, since both situations would trigger the strain release. The only way to deal with strain which occurs during kiln working is to release it by annealing.

Annealing is a branch of science and is dealt with effectively by authorities like Shand. This chapter is an introduction to the subject and suggests some commonsense methods of achieving likely conditions for minimum strain creation and its simple release. Tables do exist which make it possible to calculate the desirable annealing cycle for given types and weights of glass. Their consultation and use for specific productions is strongly recommended. The difficulty, however, is that with the type of kiln activity employed for one-off production, the circumstances which affect annealing vary considerably between pieces. The weight of a mould, variations of thickness within the glass object, disposition within the kiln all alter the basic equation. Industrially, annealing cycles are calculated for one object, and once this has been established the repeating of that single item makes it possible to repeat all the conditions of that annealing schedule.

Nevertheless, there is still much that can be done to set up a likely annealing situation and, with experience, develop a working, if crude, empirical knowledge for most situations. This can be supplemented by using scientific data and calculations where necessary.

It is fairly simple to discover the transformation temperature of the glass which is being used. The next step is to get the glass piece through this band with a variation of no more than $3°-4°$ existing within the whole. The best way of achieving this is to create a kiln environment in which temperature imbalances are unlikely to occur, then hold the glass at a point which is right at the top of the transformation band for a time to allow the internal temperature differences to even out, and then to bring it gradually down through the band. These rates, soak time and rates of temperature descent are dependent on the thickness and variation in thickness in a piece of glass. An extreme example is the mount Palomar telescope lense which was cooled from $500°-300°$ at the rate of $1°$ a day drop, and was two years in annealing. More usable examples are given in the annealing tables.

One great advantage that the craftsmen posesses over industry is that the scientific calculations are employed to find the *minimum* time in which it is possible to cool an object for economic reasons. If one is not as concerned with rapid production and efficient use of plant space, it is possible to substitute time for science. Tiffany was not a mass-producer of articles, and he achieved annealing by lengthy overkill methods. All of his factory's production was put through a cooling schedule which lasted a week. In the simplest possible terms, therefore, an annealing cycle involves holding transformation temperature, which is actually annealing point $+5°C$ for a given time, depending on weight and thickness, and then dropping the temperature very slowly.

Having established the transformation point relevant to the glass in use, the next thing to establish is the thickness of the glass. This is obviously simple in the case of a sheet or block, but in cases where variations occur the thickness is always the part furthest away from an outside surface. In this way it will be seen that annealing from one side only, as in the case of a glass sheet supported on a kiln shelf, effectively doubles the thickness and therefore the minimum acceptable annealing time. Tables contain calculations for annealing from one side or two, as in the case of free standing blown objects within a lehr.

A critical requirement is an efficient temperature recording device. If a pyrometer is 20° out in its assessment of the temperature, the annealing time has to be doubled to compensate. It is therefore important to try and establish that the temperature reading is taken from a point as close to the surface of the glass as possible. An ideal situation is to have a number of thermocouples at different points within the kiln, including one which is virtually in contact with the glass. This will enable you to discover whether the temperature is even throughout the kiln, a situation vital to annealing.

Try to create a kiln situation where imbalances are less likely to occur. It is important to realise that we are trying to create a balanced temperature between two different parts of the glass mass, the skin and the interior, and that they both cool by contradictory methods. The surface is cooled by losing heat to its surroundings and the interior is cooled by conducting its heat to the surface(s) of the glass. The surface is therefore always at a lower temperature than the interior. The variation between the hottest and coldest parts of the glass mass must not be greater than 3°–4°.

It will be obvious that some shapes will anneal more easily than others. In my experience the most difficult is an object which has wide and sudden variations of thickness, so that it may contain thin areas juxtaposed with large heavy sections. The problem of keeping the points in the middle of the heavy section and the extremes of the thin sections within a 3°–4° range is a hard one. A complication is that most kiln formed objects are by definition supported along one side by moulds, props or batts. As a result heat can only be lost effectively from the surface exposed to the air inside the kiln, and this makes them into candidates for annealing from one side only. In this sense suspended kiln formed objects are the easiest to anneal.

There are safeguards to counterbalance heat gradients within objects. The avoidance of radiant (direct) heat from element or flame has already been mentioned in connection with thermal shock whilst taking the kiln up in temperature. The use of ceramic baffles extends to preventing too rapid and uneven heat loss by virtue of the heat which they have retained and which they release gradually to the kiln interior.

In mould design it is possible to minimise this problem. In the case of a shallow mould, or sheet work where imbalance is likely, due to size and thickness variations, it is possible to incorporate lids which can be placed over the glass after it has formed, or carry out the operation within a sagger rather like casserole cooking. This militates against visual control, so the lid can be placed next to the sagger until after the glass has formed, and then placed on with a wooden stick at the start of the annealing range. This creates an even environment for heat loss and evens out the natural inbalance between skin and interior mass by placing a warm barrier between the skin and the colder kiln air.

In the case of large sheet glass fusings it is possible to place rows of H.T. bricks round the glass and to balance another kiln batt on top of them so that the glass is sandwiched between layers of ceramic. To visually monitor fusing or draping, the top batt can be placed on the bricks, leaving a gap for inspection, and then slid forward to cover the glass fully at the start of annealing.

An obvious precaution is not to open the kiln during annealing, and to close up viewing ports and unused ventilation holes; in the case of gas kilns, once the gas is off the chimney and dampers must be closed. If 99% of an object is even in temperature and 1% is colder or hotter to any extent, that is sufficient to create strain. It is important to have an even input of heat into the kiln; it is not for instance sufficient to turn on one burner or element to maintain an annealing temperature unless the kiln has circulating air devices. It is better to have all

burners or elements low or even intermittently to hold temperature.

If one part of a glass object is buried in sand, or deep within a mould, it is important to keep those parts which are exposed warm too. In addition to saggers, it is possible to make other devices to prevent rapid heat loss. A folded cone of ceramic fibre paper can be placed over pieces prior to annealing, or large dense forms can be placed near exposed glass to act as heat banks. Prior to automatic lehrs, large cobble stones used to be placed evenly throughout the lehr to act in this way. A well insulated kiln is another good starting point. The recently developed ceramic blanket packs can reduce heat loss by up to 40% and affect running costs as well as improve annealing. By filling a kiln with smoke and closing the door it is possible to see the escape routes taken by the smoke and therefore pinpoint the areas of greatest heat loss.

In planning objects, the avoidance of sudden juxtapositions of thick and thin, and excessive variation of these, are ways of designing to avoid problems.

No amount of annealing will remove certain types of strain from glass. Strain caused by mixing glasses of different types and compatibilities is inherent in their coefficients of thermal expansion differences, and therefore non-releasable. It is important to establish the likely compatabilities of the glasses you wish to mix. Usually this can only be done by buying from a supplier who will guarantee this. Otherwise small pieces can be fused together to test their compatability.

It is necessary to be able to distinguish between a crack caused by incompatability and one caused by annealing strain. Annealing cracks tend to run from the surface of the glass to the interior dividing the piece as a whole; such cracks will run across colours without deviation. Generally they describe the tension which exists between surface and interior and it is easy to see them as a stress release pattern. With incompatibility, cracking occurs around and horizontally underneath the offending colour; in extreme cases incompatible pieces will crack away from the main piece completely.

A fault which does not relate to annealing, but is caused by high, sustained temperature, reveals itself as a white scum on the glass surface. This is de-vitrification and is very common in kiln work. It only forms above a certain temperature which varies with glass types but is usually in excess of 800°C (1472°F). It is caused when the surface skin of the glass loses some of its constituents due to prolonged incandescence. Consequently it shrinks and crystallises; the scum can be removed with dilute hydrofluoric acid but it is much better to avoid its development in the first place.

Do not allow the temperature to rise higher or longer than absolutely necessary, it is good general advice anyway to persuade the glass to perform at as low a temperature as possible. Once the glass has performed, reduce temperature quickly to just above annealing point and hold it there for a while to normalise before going on with the schedule. The measure already mentioned by which baffles are used to protect the glass from radiant heat also helps to avoid de-vitrification conditions. Glass which is placed in the kiln in a dirty or dusty condition is more likely to de-vitrify than glass which has been cleaned with ammonia, methylated spirits or distilled water.

Annealing schedules

An annealing schedule consists of four sections.

1 Heating to, or cooling to the annealing point of the specific glass + 5°C (41°F) and holding that temperature for a given time.

2 The reduction of temperature at a given rate from the annealing point to a calculated position somewhere below the strain point of specific glass.

3 A constant reduction through the next 50°C (122°F).

4 The final, fast reduction from that point to room temperature.

The information required to calculate a schedule consists of three points.

1 Thickness of the glass.

2 Annealing point of specific glass.

3 Strain point of specific glass.

Annealing and strain points of common glasses

AP = Annealing point
SP = Strain point

Soda lime glass (window)	AP 552°C (1025°F)	SP 525°C (977°F)
Full lead crystal	AP 450°C (842°F)	SP 420°C (788°F)
Borosilicate (heat resisting)	AP 565°C (1049°F)	SP 530°C (986°F)

Annealing tables

Using the tables in *Glass Engineering Handbook* by Shand, and taking glass of an average soda lime type, the following examples are sample minimum annealing schedules for various weights, taking AP552°C (1025°F), SP525°C (977°F). Note that the rates of temperature loss can be slower but not faster than those quoted. (The temperatures in the following tables have been given in centigrade only).

6mm ($\frac{1}{4}$ in) thickness from one side

1 hold at AP+5° (557°) for 15 mins	15
2 reduce to SP − 10° (515°) at 1° per min	42
3 reduce next 50° (to 465°) at 2° per min	25
4 reduce from 465° to 60° at 11° per min	37
total annealing time	*119 mins*

6mm ($\frac{1}{4}$ in) thickness from both sides

1 hold at AP + 5° (557°) for 15 mins	15
2 reduce to SP − 10° (515°) at 4° per min	10·5
3 reduce next 50° (to 465°) at 8° per min	6·25
4 reduce from 465° to 60° at 50° per min	8
total annealing time	*39·75 mins*

12 mm ($\frac{1}{2}$ in) thickness from one side

1 hold at AP + 5° (557°) for 30 mins	30
2 reduce to SP − 20° (505°) at ·3° per min	173
3 reduce next 50° (to 455°) at ·6° per min	83
4 reduce from 455° to 60° at 3° per min	132
total annealing time	*418 mins*

12 mm ($\frac{1}{2}$ in) thickness from both sides

1 hold at AP + 5° (557°) for 30 mins	30
2 reduce to SP − 20° (505°) at 1° per min	52
3 reduce next 50° (to 455°) at 2° per min	25
4 reduce from 455° to 60° at 11° per min	36
total annealing time	*143 mins*

25 mm (1 in) thickness from one side

1 hold at AP +5° (557°) for 90 mins	90
2 reduce to SP − 40° (485°) at ·1° per min	720
3 reduce next 50° (to 435°) at ·2° per min	250
4 reduce from 435° to 60° at ·75° per min	500
total annealing time	*26 hrs*

25 mm (1 in) thickness from both sides

1 hold at AP + 5° (557°) for 90 mins	*90*
2 reduce to SP − 40° (485°) at ·3° per min	*240*
3 reduce next 50° (to 435°) at ·6° per min	*83*
4 reduce from 435° to 60° at 3° per min	*125*
total annealing time	*9 hrs*

38 mm (1½ in) thickness from one side

1 hold at AP + 5° (557°) for 270 mins	*270*
2 reduce to SP − 80° (445°) at ·03° per min	*3733*
3 reduce next 50° (to 395°) at ·06° per min	*833*
4 reduce from 395° to 60° at ·19° per min	*1763*
total annealing time	*4·6 days*

38 mm (1½ in) thickness from both sides

1 hold at AP + 5° (557°) for 270 mins	*270*
2 reduce to SP −80° (445°) at ·1° per min	*1120*
3 reduce next 50° (to 395°) at ·2° per min	*250*
4 reduce from 395° to 60° at ·75° per min	*447*
total annealing time	*35 hrs*

50 mm (2 in) thickness from one side

1 hold at AP + 5° (557°) for 810 mins	*810*
2 reduce to SP − 160° (365°) at ·01° per min	*19200*
3 reduce next 50° (to 315°) at ·02° per min	*2500*
4 reduce from 315° to 60° at ·05° per min	*5100*
total annealing time	*19 days*

50 mm (2 in) thickness from both sides

1 hold at AP + 5° (557°) for 810 mins	*810*
2 reduce to SP − 160° (365°) at ·03° per min	*6400*
3 reduce next 50° (to 315°) at ·06° per min	*833*
4 reduce from 315° to 60° at ·19° per min	*1342*
total annealing time	*6·5 days*

Educational aspects

Any academic discipline, by definition, has abstract educational reasons for its practice, separate from the need which inspired the original activity. One of the most esoteric in school curricula, for example, is the study of Latin, the abstract benefits of which are the development of organisational skills which the study of a dead language can give.

It has long been recognised that intelligence manifests itself in other than purely academic ways, and terms like visual thinking have been coined to cover those creative skills which manipulate visual data. The use of material handling experiences within an educational framework have become a feature of recent developments – education through materials rather than in them.

By virtue of its mystery and exclusive past, glass has been and is seen solely as a material to make objects from, and when it does enter the educational system it is at a late and therefore specialist level. As a result its educative value is limited to the course which its use describes, and its general, abstract potential is lost.

The techniques introduced in the previous chapters vary in the amount of special plant and machinery necessary for their practice. At its simplest (and therefore at its most accessible to general school and college applications) it is also at its richest educationally. However it is not just technique which makes glass educationally valuable, but a unique set of learning experiences which can be gained from contact with it.

The most obvious of its properties are transparency and fragility, but we have seen that its forming language is as unique as its range of physical properties. The variety of forms which it can be made to adopt at room temperature is wide and the transformations which occur in these forms via heat and decreasing viscosity is remarkable. Unlike ceramic, whose school facilities it can so easily use, glass alters its form on heating, and is therefore well suited to simple programmes of learning which cannot be undertaken with any other material.

When confronted with a new, but easily available material, as glass is to most students, any simple experiment with it is valid to acquire basic information. The knowledge that glass bends, stretches and flows under the dual influences of heat and gravity can be discovered in a basic set of experiments. What can be very rewarding however is, once this stage has been passed, to set up a chain of experiments with each one based on the results of the previous ones. By intelligent observation of the behaviour of a given configuration of glass, certain predictions can be made about its likely behaviour in new circumstances. In this way the excitement which experiments generate can be allied to observation, prediction and eventually selection (figure 175). Glass deforming within a kiln, and around constraints supplied by the student, is direct and visually accessible and offers very different opportunities for expression, experience and creativity from wood, metal or other general craft materials. Some of the most sophisticated glass objects made by students who have worked with me (figures 179–182 and 187) have emerged from such an early experimental series.

175 A kiln exercise: a ceramic container filled with contrasting lumps of glass is tipped when the glass is molten, and frozen to retain the result.

The first experiment asks the basic question 'What happens if?'; the last experiment demonstrates just what glass can be made to do with that knowledge. Glass is, as we have discovered, a very active partner in the production of any form.

Recent developments in sculpture have moved away from monumental form to examine and use materials not usually associated with fine art activities, e.g. paper, rope, sand, wire, ice etc. Such novel materials are often employed in situations which exploit their physical qualities: tying, bending, stretching etc. An extensive use of glass within the general educative system would mean that it could also assume its rightful place alongside other materials as basic components for a wide variety of purposes from educational to expressive. Such a move would eventually enrich the more specialist uses of glass.

I have found that glass remains an unknown and therefore obscure material with magical connotations. Many of those who work in glass are anxious to retain its unknown quality (unknown in the sense that while most people have some idea and experience of the forming methodologies of wood and metal, they are usually ignorant of how even simple glass objects are made). The fear

176 Detail of a dish by Frank Jurrjens, fused from six pieces of glass, and decorated by sieved enamel, stencilled lustres and commercial transfer decals.

177 A sagged piece by Gina Clarke, in which the enamelled glass has been allowed to flow over the plaster former onto another below it.

155

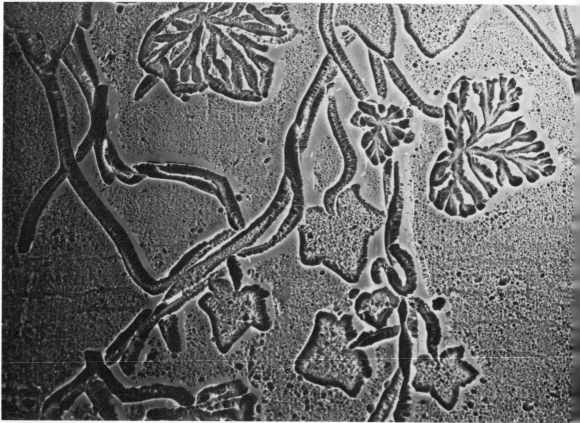

178a *Top* A flat bed mould consisting of a collage of ceramic fibre paper.

178b Detail of a piece by Anne Johnson, made by sagging glass over this mould.

on the part of the artist seems to be that its magic and unique position would disappear if it were better understood and more universally handled.

In my opinion, the study, exploitation and historical understanding of glass makes an appraisal of skill and artistry more possible. Once the 'How' is known, the 'Why' can be fully appreciated.

It has not been my intention in writing this book to pronounce the last word on the subject of heat forming glass. It is an attempt to widen the scope of the material on many fronts and at many levels.

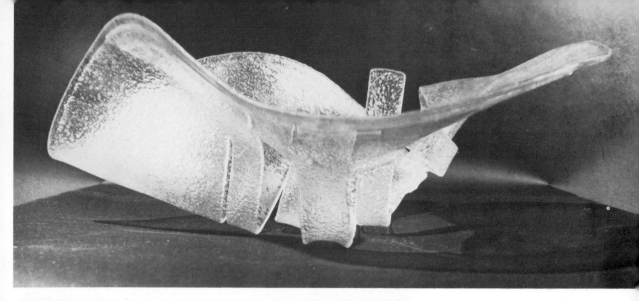

179 Sculpture by Paul Hughes – a sophisticated piece of kiln manipulation. It involves fusing and texturing a sheet made from separate sections and by combining support and suspension points creating variations within the sheet.

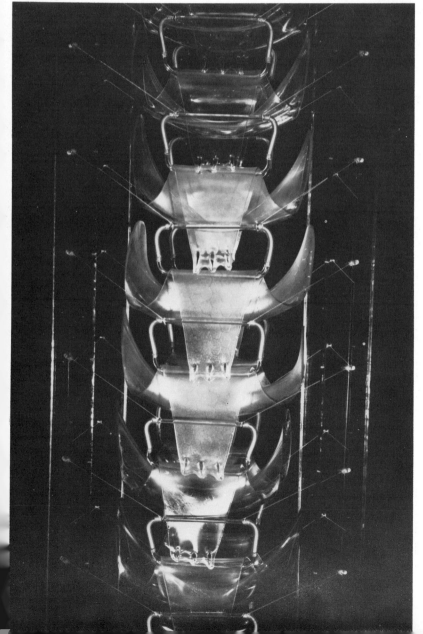

180 A suspended column by Kay Hassall (see figures 114 and 115 for the techniques used).

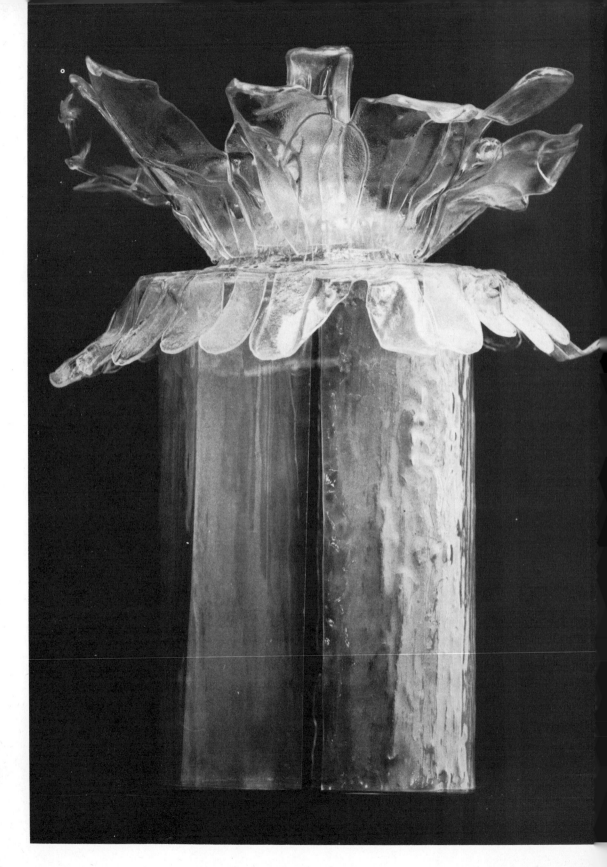

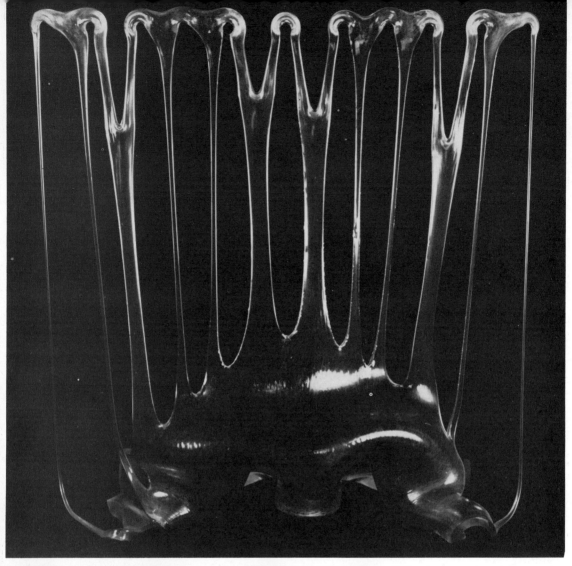

181 *Opposite* A construction by David Reekie – a combination of fused and bent sheet glass elements.

182 *Above* A suspended piece in 12 mm ($\frac{1}{2}$ in) thick sheet glass by David Thornley. This beautifully controlled form was the result of numerous experiments.

183 Twisted rods fused together and polished. The result is very close to the reticelli bowls.

184 *Above* Bowl by Frank Jurrjens.

185 *Above right* Detail of a piece by Frank Jurrjens, made from canes (cross-sectioned and as lengths), fused, polished and mounted on a metal base.

186 Glass blocks by Anne Johnson, fused from rods in metal moulds, cut and polished.

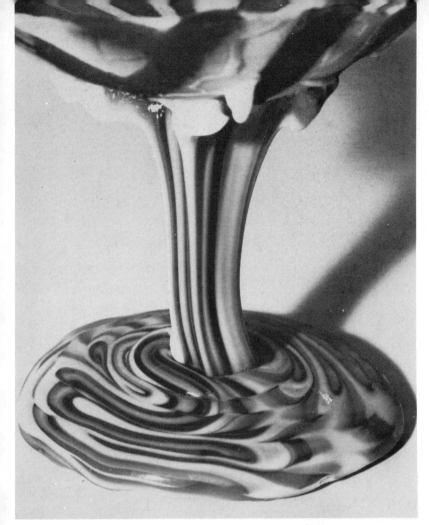

187 A kiln poured piece by Roger Calow. Alternating rods are placed in a mould around an aperture and the multicoloured flow folds and spirals onto a mould below.

188 Detail of the kiln poured piece.

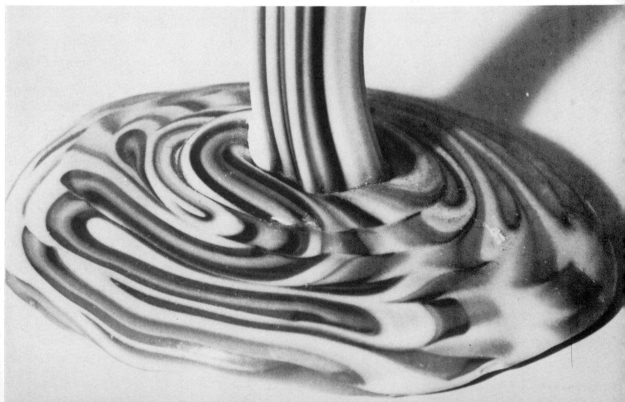

189 Sculpture 'Hera' by Clifford Rainey: a combination of glass casting, brass and marble.

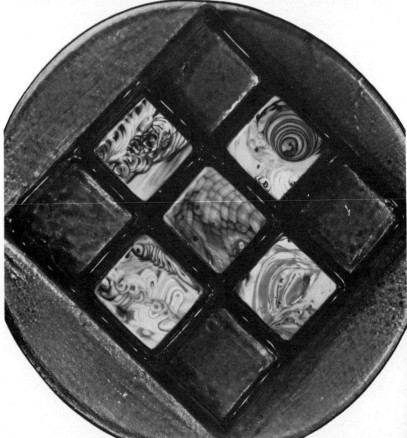

190 Detail of a dish by the author. The basic form was kiln cast from a glass blank into a casting mixture mould. The mosaic sections were cut from kiln poured marbled sheets.

191 *Opposite* Detail of a dish by the author: a combination of kiln casting and hot glass pouring.

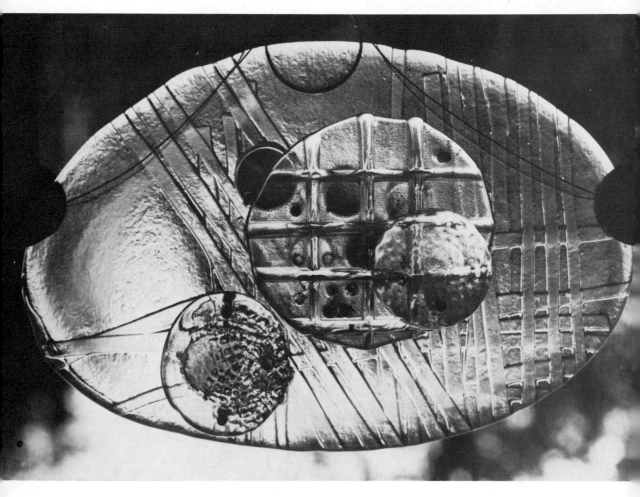

192 A constructed form by the author: a combination of cast forms and lenses.

Bibliography

Brill, Oppenheim, *Glass of Mesopotamia*, Corning, New York, 1970
Douglas, R N and Frank, S, *A History of Glass Making*, Foulis, 1972
Duncan, Alastair, *The Technique of Leaded Glass*, Batsford, London, 1975
Engle, Anita, *Readings in Glass History, Vols 1–10 Jerusalem*, Phoenix, 1977
Fossing, Paul, *Glass Vessels Before Glass Blowing*, Copenhagen, 1940
Fukai, S, *Persian Glass*, Weatherhill, New York; Tankosha, Japan, 1977
Gardi, R, *African Crafts and Craftsmen*, Van Nostrand Reinhold, 1969
Jones, G, *Glass*, Chapman & Hall, London, 1971
Journal of Glass Studies, Corning Museum (published annually)
Littleton, Harvey, *Glass Blowing: A Search for Form*, Van Nostrand
Reinhold, 1971
Maloney, F, *Glass in the Modern World*, Aldus, London, 1967
Neuberg, F, *Glass in Antiquity*, Rankin, London, 1949
Otto, Frei, *Pneumatic Structures*, Crosby Lockwood Staples, St Albans, 1976
Reyntiens, Patrick, *The Technique of Stained Glass*, Batsford, London, 1977
Schuler, Frederick *Glass Forming*, Pitman, London, 1971
Shand, E B, *Glass Engineering Handbook*, McGraw-Hill, 1958

List of suppliers

UK and Europe

Glass rod and lump
Plowden and Thompson Ltd
Dial Glass Works
Amblecote
Stourbridge, West Midlands

Enamels, American turps screen medium
C J Baines & Co Ltd
Sutherland Works
Stoke-on-Trent, Staffs

Lustres
Engelhard Industries Ltd
Hanovia Liquid Gold Division
Valley Road
Cinderford, Glos

Antique sheet glass and slab
Thomas Hetley Ltd
Beresford Avenue
Wembley, Middx

Ceramic fibre
The Carborundum Co Ltd
Rainford
St Helens
Merseyside WA11 8LP

Crucibles
Thermal Syndicate Ltd
Maxwell Road
Stevenage, Herts

Grain, powder, ingots
Klaus Kugler
Glaswaren Fabrikation
8903 Haunstetten Bei Augsburg
Wachel Strasse 12
Postfach 44
West Germany

USA and Canada

Glass rod, sheet
Nervo Distributors
650 University Avenue Box 7
Berkeley
California 94710

Enamels and lustres
Ferro Enamel Co
4150 East 56th Street
Cleveland
Ohio

Ceramic fibre
Carborundum Co
5240 St Charles Road
Berkeley
Illinois 60163

Crucibles
Ipsen Ceramics
Alco Standard
325 John Street
Pecatonica III 61063

Powders, beads, grain, millefiore cane
Houde Glass
1177 McCarter Highway
Newark
New Jersey 07104

Hand rolled glass
Canadian Art Glass Ltd
PO Box 550 Station T
Calgary Alberta
Canada T2H 2HI

Index